0071065

COLLIN COUNTY COMM

D1204603

DATE DUE

JUN 2 2 1994	
NOV. 1 6 1994	

Ogden, Jack.

Ancient jewellery.

$10.00

BAKER & TAYLOR BOOKS

Ancient Jewellery

INTERPRETING·THE·PAST

ANCIENT
JEWELLERY

Jack Ogden

University of California Press/British Museum

Acknowledgements

This small book is dedicated to my parents, who encouraged my love of antiquity from an early age, and in particular to my father, who has taught me so much about craftsmanship and jewellery, opening my eyes to both the art and the technology.

I am indebted to Nina Shandloff at British Museum Press for her patience and wisdom during the preparation of this work, and to various colleagues who read the manuscript and made useful comments. Any errors that remain are, I hope, my own. The following museums and individuals have kindly allowed me to reproduce the objects illustrated in the figures listed below (the remaining photographs and diagrams are my own):

Ashmolean Museum, Oxford: **26**; Trustees of the British Museum, London: **cover, 2, 4, 5, 6, 8, 9, 12, 17, 18, 21, 23, 25, 28, 33, 34, 38, 40, 41, 42, 43**; John Gwinnett and Leonard Gorelick: **22**; M. G. Lefebvre, *Le tombeau de Petosiris*, Cairo, 1923: **24**; The Manchester Museum, University of Manchester: **19**; The Metropolitan Museum of Art, New York: **7, 20**; Petrie Museum, University College London: **36**; Sheffield City Museum: **3**

University of California Press
Berkeley and Los Angeles

© 1992 The Trustees of the British Museum

Designed by Andrew Shoolbred

Printed in Great Britain

Library of Congress Cataloging-in-Publication Data
Ogden, Jack.
 Ancient jewellery/Jack Ogden.
 p. cm.—(Interpreting the past)
 Includes bibliographical references.
 ISBN 0–520–08030–0 (pbk. : alk. paper)
 1. Jewelry, Ancient. I. Title. II. Series.
 NK7307.O337 1991 92-3263
 739.27′093—dc20 CIP

Cover illustration: Some of the jewellery from the hoard known as the Thetford Treasure, found in Norfolk in 1979 and dating from the late 4th century AD.

Contents

Preface

The subject of this book is ancient jewellery, particularly that made in the Near Eastern and classical Mediterranean world: what we know about it, the means by which this information can be obtained, and how we can use it to help us interpret the past. Clearly it is not enough to look at a piece of jewellery and say that it is beautiful (or not); the art historian or archaeologist must delve deeper. This can be done either literally by using scientific examination and analysis, or by attempting to understand the aesthetic and social factors that led to its creation and use. The scientific approach is the prime concern of this book.

Jewellery is frequently relegated to the class of so-called minor arts; but though this is true in terms of scale, the importance of jewellery in the study of ancient art and techniques and in the understanding of ancient social, religious and economic history must not be underestimated. The skill of an artist does not necessarily depend on the scale of his work; craftsmen from the time of the Egyptian pharaohs up to Cellini himself were proud to call themselves goldsmiths and sculptors.

The fact that jewellery has inspired such a wide gamut of strong emotions through the ages, ranging from greed and envy to religious piety and secular veneration, brings us into contact with the sentiments of individuals and their societies in an unusually direct way. The ornaments worn by an average well-to-do Egyptian, Greek or Roman can provide a far better insight into their personal beliefs and aspirations than can the stone sculpture erected in their temples and city squares.

There is only space here for an introduction to the study of jewellery, aimed at the general reader who wishes to better understand the jewellery seen in museums and other collections. It is also hoped that this book will be of value to archaeologists and students who wish to familiarise themselves with a class of object that is sadly often ignored in archaeological and art historical teaching.

The brief bibliography at the end of the book lists some of the relevant publications (mainly in English) on ancient jewellery, and the interested reader is urged to consult these and the more detailed references given in them.

— 1 —

Jewellery and the Archaeologist

From the archaeological point of view, jewellery should be treated as just one more variety of object that has survived from the ancient world, one more piece in the jigsaw puzzle of history. Unfortunately, human nature and the natural lure of 'treasure' work against this. The discovery of ancient jewellery is sometimes greeted with more enthusiasm by the media than by archaeologists and, indeed, its archaeological significance is seldom demonstrated by the publicity it receives as riches displayed in glossy books or in crowded exhibitions.

Of course, precious metal objects are rarely found in the average excavation and we can understand, if not excuse, the immense time and energy that have been devoted to, say, pottery classification compared to that expended on earring typology. Nevertheless, jewellery is an important part of the evidence that has survived from ancient times.

We can study jewellery from the point of view of its raw materials or the techniques by which it was made, and thus we can infer details of ancient economy, trade and workshop practice. We can also examine jewellery from the art historical perspective and see how its designs and iconography relate to other art forms. In addition, we can search ancient literature for written references to jewellery and examine all types of representational art – from wall paintings to terracotta figurines – for insights relating to the use and significance of jewellery. It is remarkable how often jewellery types in collections can be matched with depictions in other art forms.

So far there is no scientific means of dating metals in the way that radiocarbon can be used to date organic materials or thermoluminescence to date ceramics. The dating of jewellery is therefore based primarily on dateable finds found with it and comparable objects from other sources. The literary and representational evidence noted above can also often give dating guidelines. For most categories of ancient jewellery we can date an individual object to within a century or so on the basis of style and technique and sometimes a date can be suggested within a generation. Dating can become an obsession, but in reality an understanding of sequences and interrelationships is often more valuable than precise chronological dates.

Reconstructing the past

The diverse ways of studying jewellery – from metallurgical to philological – should not be viewed as alternatives, but as necessary combinations of approaches that help build up a complete picture of the past. Gold jewellery is not blighted by the decomposition and corrosion that affect most other metals and so it often survives in relatively pristine condition. Unlike many artefacts, we can readily understand how it was intended to appear to its original owner and recognise traces of tool marks and other clues as to its construction, use or adaptation.

The marks left by the tools used in the manufacture of a piece of jewellery will tell us much about how it was made, reflecting both the processes typical of its period of manufacture and the idiosyncracies of the individual craftsmen. Tool marks are also vitally important in the study of suspected forgeries. Quite often close inspection will reveal repairs or adaptations and these can be informative about the object's ancient (or sometimes modern) history. Wear on jewellery is also of interest. Signs of wear, along with considerations of sturdiness, can indicate if an ornament was intended for use or purely for funerary purposes.

Earrings and rings frequently show wear, sometimes to a considerable extent. In one case, microscopic examination of two Roman gold rings, now in a private collection and said to have been found together, showed tool marks which revealed that both rings had been made by the same goldsmith. Wear on the sides of the rings also showed that they had been worn next to each other on the same finger. Thus an experienced archaeologist can say that these rings were made at the same time in the same workshop, belonged to the same owner who wore them together on one finger, and believe the report that they were buried together. The actual rings cannot tell us which finger they were worn on but, on the basis of ancient literary information and visual representations of rings in wear, we can say that in all probability the two rings were worn together on the little finger of the left hand of a woman. With some classes of rings we can be even more specific. For example, representations and occasional *in situ* finds suggest that in Roman times snake rings were almost invariably worn on the third finger of the right hand, and an archaeologist with specialist knowledge of ancient religion and superstition could probably tell us why.

When technical information is combined with textual and representational information we can sometimes form a surprisingly comprehensive account. As an example, we can take the snake armlet in figure 1. On stylistic grounds we can tell that this solid gold ornament comes from Egypt and dates from the time of Roman rule in the first century AD. Analysis has shown that it is composed of quite high-purity gold, around 93–4 per cent pure gold – which in modern

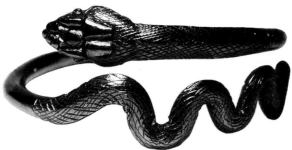

1 Gold coiled-snake armlet. The second, smaller head at the end of the tail is typical of the snake armlets from Roman-period Egypt. 1st century AD. Private collection.

terminology is about 22 to 23 carat (that is, 22–3 parts per 24). Trace elements reveal that the gold originally came from alluvial deposits and, from what we know about gold distribution, was quite probably refined prior to slight debasement with silver and copper. Microscopic examination reveals that this armlet was made by casting a gold rod and then hammering and chasing it into the final shape (see chapter 4). Microscopic examination also allows us to determine the variety and form of the tools employed and the exact sequence of shaping and decorating. From the position of inclusions in the gold and knowledge of their behaviour in molten gold, we can even deduce the orientation of the armlet relative to the simple open casting-mould. From records on papyrus we know that such armlets were probably made to order for the customer and we can calculate from its weight of 116.2 grams that it probably cost about 1300 drachmae – the equivalent of about three years' pay for an agricultural foreman in Roman Egypt at that period. On the basis of funerary paintings and other representations we can surmise that this armlet was one of a pair worn on a woman's upper arm. The orientation of the head on this one shows that it was destined for the left arm – they were worn with the head uppermost and pointing inwards. Slight wear on the surface shows that it was worn in life and not just as a funerary ornament. In general, the snake had a complex and extensive symbolism in antiquity and, while we cannot be sure of the exact meaning this armlet held for its original wearer, it was certainly meant to be protective and probably intended to ensure health or fertility, or both.

Silver jewellery is affected by burial and the passage of time to a far greater extent than gold, and base-metal ornaments are even more susceptible to change. This means that such objects rarely provide pristine surfaces for the study of tool marks and techniques, but, nevertheless, any ancient object can provide useful evidence for those who are trained to look.

Most ornaments, if examined closely, will let us determine how they were made and the extent to which they were worn. Once into the Roman period there are few ornament types that do not appear in at least the occasional representation. Ancient writers were remarkably vague when describing jewellery and only a few jewellery types seem to have had specific names. However, continued study of ancient literary texts, ancient glossaries and even humble lists on papyrus fragments is constantly increasing our knowledge of ancient jewellery terminology.

The history of jewellery collecting

Interest in ancient jewellery is itself of considerable antiquity, although it is not easy to discern when archaeological rather than treasure-seeking motives first appeared. The use of earlier ornaments in their original form – rather than recycling them for their material – must imply genuine admiration, probably combined with a certain amount of superstition. King Shoshenq II of Egypt (about 890 BC) was buried with some wonderful jewellery, including a gold bracelet made to hold a Mesopotamian lapis cylinder seal that was already some 1400 years old. Many medieval signet rings are set with Roman intaglios, reused and reinterpreted in line with contemporary Christian sentiment. For example, a portrait head of a Roman emperor engraved on a seal could have been taken to be that of John the Baptist. In the Renaissance, ancient engraved stones were similarly collected and the great Renaissance goldsmith Cellini comments on discoveries

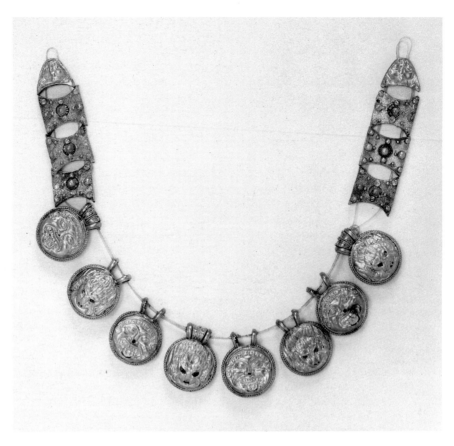

2 Part of a gold necklet with eight circular Gorgon-head pendants, six spacer plates and two stylised lion-head terminals. The original form of the necklet is uncertain. *c*. 6th century BC. Formerly in the collection of Sir William Hamilton, purchased by the British Museum in 1772. BMCJ 1460.

of ancient jewellery and the quality of work on ancient gold. Nevertheless, only a limited number of ancient gold ornaments discovered before the eighteenth century have survived to this day intact – ignorance, greed and revolution have all taken their toll.

Archaeological interest in jewellery began in earnest in the eighteenth century. In part, this was inspired by the excavations at Pompeii and Herculaneum which began in the mid-1700s. Some jewellery from this region and elsewhere in Italy was acquired by the British Ambassador at Naples, Sir William Hamilton, and later purchased for the British Museum, where it formed a basis for the ancient classical jewellery collection (fig. **2**). Great Italian families assembled or increased their collections: some of the gold jewellery now in Naples Museum originally came from the Borgia and Farnese families. However, Italy was not the only place for the discovery of jewellery in the eighteenth century. In Britain, this same period saw the discovery of several fine examples of Anglo-Saxon jewellery – the brooch in figure **3** was found in a Derbyshire barrow in about 1767. By the beginning of the nineteenth century good collections of ancient jewellery could be found in museums in Europe and North America.

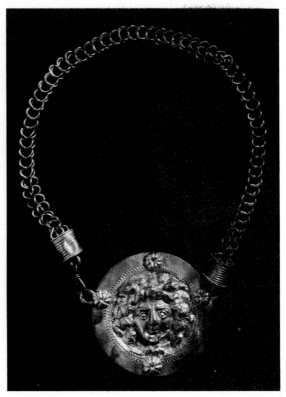

3 (*above*) Anglo-Saxon gold disc-brooch decorated with intricate filligree work and set with flat-cut and cabochon garnets, mid 7th century AD. Found in about 1767 in White Low barrow on Winster Moor in Derbyshire, England. Formerly in the Bateman Collection, now Sheffield City Museums.

4 (*right*) Gold loop-in-loop chain necklet with Medusa-head centrepiece, a typical ornament from Egypt during Roman rule in the 3rd century AD. Formerly in the Franks Collection, now British Museum, BMCJ 2737.

Many major private collections were built up over the last century or so, including those of Antonio Benaki, the Cavaliere Campana, Alessandro Castellani, Louis de Clercq, Sir Augustus Franks (fig. 4), Eduard Gans, Friedrich von Gans, E. Guilhou, Ralph Harari, J. Pierpont Morgan (fig. 20), A. J. von Nelidow, Marc Rosenberg, Adolf Schiller, Hélène Stathatos, Michel Tyszkiewicz and Henry Walters.

Some of these collections – such as the Franks, Stathatos and Benaki collections – have remained largely intact, while others have been disseminated by private sale or public auction – notably the Guilhou and Harari ring collections. Some objects pass through many hands before coming to rest in a museum. For example, the Nelidow Collection, built up in the late nineteenth century, was obtained by the Soviet state at the time of the Russian Revolution and then sold by the Hermitage Museum, Leningrad, at Sotheby's in London in 1931. Some goldwork from the collection is in the Fitzwilliam Museum in Cambridge, other pieces are still in private hands and reappear on the market at regular intervals.

Initially most ancient jewellery was in dealers' or private hands before being given or sold to national museums, but by the end of the nineteenth century official excavations by museums and learned societies were providing finds directly to museums. For example, British Museum excavations on Cyprus in 1896 provided a fine collection of Mycenaean goldwork for that institution. In other instances a combination of academic excavation and business prevailed – the Egyptian authorities allowed the excavator Flinders Petrie to keep some of the important jewellery he discovered at Lahun in 1914, and this he subsequently sold to the Metropolitan Museum of Art in New York (fig. 7) to help fund further

excavation. The Egyptians only allowed Petrie to keep the goldwork because it closely duplicated finds made at Dahshur and exhibited in the Cairo Museum.

This example reflects the growing trend for countries to take an interest in their own artistic heritage and thus to refuse to allow the export of unique finds. The great treasures of Tutankhamun and from the royal tombs at Tanis had to remain in Egypt, whereas Iraq kept only a share of the goldwork from the Royal Cemetery at Ur (the remainder went to the British Museum and the University Museum in Philadelphia, Pennsylvania which had jointly organised the excavations). Nowadays very little is allowed out of the country of origin – certainly almost nothing of artistic or academic importance. We are now back in the situation where museums wishing to build up their holdings of ancient gold jewellery are forced to rely on dealers or private collectors – a situation rife with difficulties concerning provenance and authenticity.

Theft can be a problem on even official excavations. Small gold ornaments are temptingly easy to filch from an excavation and numerous excavators have suffered from dishonesty among their workers. The Egyptologist C. C. Edgar described the discovery of a large hoard of gold and silver at Bubastis in the Egyptian Delta and says how 'from the mouth of one of the workmen a flat piece of silver covered with gold leaf was extracted with some difficulty'. Some clandestinely excavated jewellery reaches museums via the art market, other pieces enter museums in their country of origin because they are claimed or seized by the authorities. The Archaeological Museum in Istanbul owns a fine Hellenistic earring of the third century BC in the form of a pendant figure of the naked winged goddess Nike with a flowing cape, found in a tomb at Izmit. The same museum also owns part of a second cape; what appears to be the matching earring – minus a cape – is in the Museum of Fine Arts in Richmond, Virginia.

Provenance and authenticity

The majority of jewellery in collections worldwide has no certain origin. This is unfortunate. Much of such jewellery derives from lucky stray finds made by farmers or peasants; a great deal comes from the looting of ancient sites and burials, in recent times aided by metal detectors. Even finds from 'official excavations' are too often poorly recorded and published.

Some archaeologists prefer to ignore all objects with uncertain or illegal origins as valueless archaeologically, but this is an overreaction. The original removal of any object from its archaeological context is often both a legal and moral crime, but for scholars to ignore it – to remove it also from scholarly discussion – merely compounds that crime.

Information about the precise archaeological context in which an ornament is found obviates any worries about authenticity and might give useful assemblages of associated finds to help build up chronological markers and geographical links. The importance of provenance for archaeology is undeniable. However, since comparisons can be drawn between excavated and unprovenanced jewellery, the more provenanced ornaments that are found, the more we can say about the unprovenanced ones. A good example is the gold snake bracelet (see p. 8): the fairly detailed description made no mention of its archaeological context, save that it was from Egypt. All the information was gleaned from the study of the armlet itself plus details obtained from literary and pictorial sources. This type of broad-based study of jewellery is the subject of this book.

A major problem with unprovenanced jewellery is that we cannot always take age for granted. Indeed, the examination of ancient gold jewellery is often prompted by the need to establish authenticity. At present, science and art history cannot conclusively prove authenticity for much unprovenanced ancient gold but, in practice, specialist examination can usually establish authenticity with near enough certainty. Nevertheless, there will always be a handful of objects of debatable authenticity whose true nature can only hang in the balance pending advances in our knowledge. In the meantime any unprovenanced object should be studied by a specialist before it is accepted as ancient. This might seem an obvious expedient, but too many curators and collectors underestimate the forger's ability.

The forgery of ancient jewellery has a long history and the fact that an object has been in one or more illustrious collections for several generations does not ensure authenticity. Some famous early fakes include the scarab-set Menes necklet and earrings which were probably made in the 1830s and the gold crown, supposedly of Queen Saitaphernes, that was purchased by the Louvre in 1895. In general, most old fakes are now readily apparent as products of their own age; they usually scream out their Victorian or Art Nouveau origins. Old adaptations of genuine objects are less readily discernible. More recent fakes are a greater problem: superb illustrations in books allow plausible stylistic copying or pastiche, while most ancient techniques are now closely imitated by some fakers. Time will surely unmask some recent fakes as having a distinct late twentieth-century look – invisible to us now – and others will fall before the onslaught of science and art history.

The excavation of jewellery

Like most archaeological artefacts, ancient jewellery has survived because it was buried. With the possible exception of the occasional ornament in a church or shrine, there are no certain instances of ancient jewellery remaining in continuous live human ownership since the time it was made.

The most obvious burial category is burial with the dead. At one extreme are the vast treasures, many of which have formed the basis of hugely successful exhibitions travelling all over the world. These include the rich Scythian tombs in south Russia, excavated from the eighteenth century onwards (Hermitage Museum, Leningrad); the tomb of Tutankhamun, discovered in the Valley of Kings at Luxor in Egypt in 1922 by Howard Carter and Lord Carnarvon (Cairo Museum); the Royal Cemetery at Ur in what is now Iraq, excavated by Sir Leonard Woolley in 1926–9 (divided between the British Museum, the University Museum in Philadelphia and the Baghdad Museum); the burial of a Saxon king at Sutton Hoo in Suffolk, England, discovered in 1939 (now in the British Museum); the royal tombs at Tanis in the Egyptian Delta, excavated by Pierre Montet in 1939–40 (Cairo Museum); the so-called tomb of Philip at Vergina in Macedonia, excavated by Manolis Andronikos in 1977 (Archaeological Museum, Thessalonika); and the recently discovered royal burials at Nimrud with their astounding goldwork (Baghdad Museum).

At the other end of the scale are the myriad of humbler burials of people of the middle and lower classes. Such burials give us a good idea of the sort of ornaments worn by the less fortunate members of those ancient societies. In the poorest graves personal ornaments, if present at all, can be limited to simple glass

beads or base-metal earrings. Slightly richer graves can contain lightweight precious metal jewellery or bronze ornaments whose lowly material is sometimes amply compensated for by fine workmanship and design.

Human burials were not the sole repositories for jewellery over the passing millennia. Jewellery, particularly precious metal jewellery, was often deliberately buried or hidden for security. Classical writers make numerous mentions of the practice, and Roman law had to cover various eventualities concerning unclaimed or fortuitously discovered hoards of this type. The large number of extant hoards shows that for one reason or another they were never reclaimed by their owners. For some ancient societies – Roman Egypt, for example – jewellery is far better known from hoards than from human burials. In general, a large proportion of the gold and silver objects seen in collections today has been found in hoards, secreted in the earth or under temple floors for safe-keeping. Some were temple treasures, others loot from robberies; often they were the family jewels – sometimes the mother's dowry. Other hoards were probably hidden by the jewellers themselves.

The Thetford Treasure, found in Norfolk, East Anglia in 1979 and consisting of some 81 late fourth-century AD objects including 22 gold rings and 33 silver spoons, is an intriguing example of a hoard. It is now on display in the British Museum (fig. 5). The exact archaeological context of the treasure is uncertain since it was a metal-detector find, but it appears to be largely intact and can be dated on the basis of the style of objects, supported to some extent by rumours of late fourth-century coins in the original find. Although much of the jewellery is without precise parallel, the general forms can be matched elsewhere in the western Late Roman empire – a small hoard from Spain, for example, contains similar rings plus early fifth-century coins. The Thetford Treasure was concealed in a cylindrical shale box and perhaps one or two pots, and must surely have been deliberately secreted either for general safe-keeping or to avoid some specific and imminent danger. The problem is hazarding a guess as to who buried it: owner(s) or thief? The majority of the objects are brand new and some are unfinished, but it seems unlikely that the hoard belonged to a jeweller: it would represent a huge stock-holding of precious metal – over half a kilo of gold and nearly a kilo of silver, a considerable fortune in ancient times. On the other hand, it is hard to understand why an individual, or even a family, would have such a large collec-

5 Three of the rings from the so-called Thetford Treasure, found in Britain in 1979. The flamboyant ring (*top left*) is set with a central amethyst surrounded by garnets and emeralds. The shoulders are in the form of stylised dolphins. The second ring (*top right*) has a bezel in the form of a vessel flanked by woodpeckers. The vessel contains a green glass. The lower ring has a beaded wire hoop and a bezel in the form of a mask of Faunus or Pan, surmounted by two garnets. *c*. 400 AD. British Museum, PRB P1981.2–1.5, 7, 23.

6 Roman gold bracelet from Pompeii, Italy, buried by the eruption of Vesuvius in AD 79. The hemispherical components are of sheet gold decorated with beaded wire, and the bracelet has a simple hinge-type fastener. This type of bracelet was typically worn in pairs. British Museum, GR 1946, 7–21.

tion of mint-condition jewellery. Possibly the jewellery was being made by a goldsmith as part of a special commission for a temple or cult centre – certainly the treasure reveals connections with the cult of Faunus.

Objects of all types were also deliberately concealed or put in holy places, such as rivers and caves, as offerings for the gods. This is an unlikely explanation for the Thetford Treasure, but it is true of other hoards. A good example is the miniature gold, silver and copper-alloy axes of about 1600–1500 BC found earlier this century in the Arklochori cave on Crete and now widely disseminated. Greek shrines can contain copper-alloy pins and brooches, often well worn, donated by owners grateful for some past event or anxious about the future. Some fine Bronze and Iron Age examples of goldwork from the British Isles might have been buried as offerings.

Accidental loss of valuable jewellery also occurred and can be exemplified by many stray finds – typically small and eminently losable objects such as single earrings, gemstones from rings and the like. It is not unusual to find ring-stones in the drains of Roman baths and sewers. However, there are also examples of losses on a far larger scale. These include shipwrecks and the wholesale loss of jewellery (along with its wearers) in the eruption of Vesuvius, near the Bay of Naples, which buried Pompeii and neighbouring areas in the first century AD.

The wealth of jewellery from the Pompeii region, though recalling the terrible tragedy that led to its burial, provides an unrivalled assemblage of ornaments from one society and from a closely dated context – 24 August 79. It is noteworthy (though seldom noted) that if it were not for the eruption of Vesuvius, we would be left with minimal first-century AD Roman jewellery from Italy in any of our collections. This underlines the fortuitous nature of archaeological discovery and shows the need for caution in any attempt to plan distribution maps. For example, the bracelet from the Pompeii region shown in figure **6**, consisting of linked pairs of thin sheet-gold hemispheres, is usually considered a typically Pompeian type. However, this same bracelet type has also survived from Roman Egypt. If Vesuvius had not erupted in AD 79 we would consider the type rare, but typically Romano-Egyptian.

Much of the jewellery from the Pompeian region has been found *in situ* on the remains of the original owner. Such archaeologically fortuitous contexts – however gruesome – allow us to see exactly how and where an ornament was worn. Sadly, in many cases, both at Pompeii and elsewhere, such information has not always been satisfactorily recorded. Our knowledge of the fingers favoured for particular types of ring is still very sketchy, largely because such basic information has not been noted by excavators. Far too often particular assemblages, backing materials or threading arrangements have not been recorded. There are

15

7 Girdle of Princess Sit-Hathor-Yunet. The sheet-gold cowrie shells are threaded with beads of gold, green feldspar and carnelian. Egypt, *c.* 1900 BC. Metropolitan Museum of Art, New York, Rogers Fund and Walters Gift, 1916, no. 16.1.5.

very few threaded bead necklaces displayed in museums worldwide that accurately record their original arrangement. Perhaps excavators are carried away by the glint of gold which, in the words of the great Egyptologist Sir Flinders Petrie, 'blinds them to everything else'.

There are, of course, important exceptions. In 1914 Petrie himself was excavating at the Twelfth Dynasty pyramid complex at Lahun in Egypt. The burial pit of the Princess Sit-Hathor-Yunet had been disturbed in antiquity, but the robbers had missed some objects including wooden jewellery caskets. These caskets and their contents were almost totally decayed and their remains and original contents stirred up in a huge mass of dried mud. Petrie's assistant, Guy Brunton, spent days carefully picking away at the dried mud, meticulously drawing the position of each minute component as it was recovered. As a result, the beautiful gold, carnelian and feldspar girdle from the find is now displayed in the Metropolitan Museum of Art, New York, in its original arrangement (fig. 7),

8 Drawing of the 'Pan' ring from the Thetford Treasure, as shown in figure **5**. The drawing shows the construction of the ring with a clarity that would be hard to obtain from a series of photographs. This drawing is reproduced from the full publication of the Thetford Treasure published by the British Museum in 1983.

along with some other jewellery from the tomb. As a sad contrast, the excavators noted that the silver objects remained as little more than stains in the mud.

Ideally jewellery, like any artefact, should be accurately recorded by drawing and photography at as many stages as possible – from its position *in situ* in the ground to its final cleaned state. The photographs and drawings should record the object precisely; artistry should not outweigh usefulness. Whether for the excavation report or exhibition catalogue, the pictures should provide the maximum amount of information for those who are unable to handle the object itself. Perhaps the best recent publication of a find of jewellery is that of the Thetford Treasure, which covers all aspects of the style, construction, weight, composition and symbolism of the hoard. It is interesting to compare the photographs and the drawings of the 'Pan' ring taken from that publication (figs. **5** and **8**) which show clearly how both drawings and photos are valuable and can complement each other. However, accurate recording also has its drawbacks – rather clumsy fakes of some Thetford Treasure ornaments have already appeared on the market.

— 2 —

Looking at Jewellery Scientifically

Jewellery was primarily a decoration for the human body or garments even when ostensibly functional, as with a fibula, or dress fastener. Even today, the sheer beauty and virtuosity of some ancient jewellery can blind an otherwise objective viewer. Too many writers of catalogues and other publications have been so swept away in rapturous phrases describing the appearance of jewellery that they provide minimal objective information about its origins, use and assembly.

Today archaeologists have such a battery of scientific processes with which they can examine jewellery that they may be tempted immediately to focus microscopes and turn on the analytical equipment. However, the first stage must be simply to look at the object with the naked eye. We need to consider its form and function, its relationship to other objects, and the best approach to its more detailed study.

The art historical approach to jewellery relies on a good corpus of published objects from which stylistic or geographical relationships can be derived. It is not surprising that most of the earliest books on ancient jewellery – whether in English, French, German or Russian – are catalogues of collections or finds from excavations. Many of these volumes, dating from the late nineteenth century onwards (such as the catalogues of the classical jewellery in the British Museum first published in 1907 and 1911), still provide the foundation for studies today.

There has also been a remarkably long tradition of the scientific examination of ancient jewellery. As we will see below, chemical analyses were being made of ancient gold objects at least by the middle of the nineteenth century. The technical examination of the assembly of ancient jewellery also dates back into the nineteenth century. Many of the early proponents were jewellers themselves, who had the necessary knowledge and metalworking experience. In the late nineteenth century, the great French jeweller Alexis Falize examined the gold jewellery found at Boscoreale in Italy and the famous goldsmith Carlo Giuliano studied the goldwork found by Heinrich Schleimann at Troy. In Italy the Castellani family were pre-eminent in the early study and replication of classical jewellery techniques, particularly granulation. They also repaired and 'improved' some ancient pieces (fig. 9). The dealer and collector Marc Rosenberg published his monumental studies on ancient goldsmithing technology between

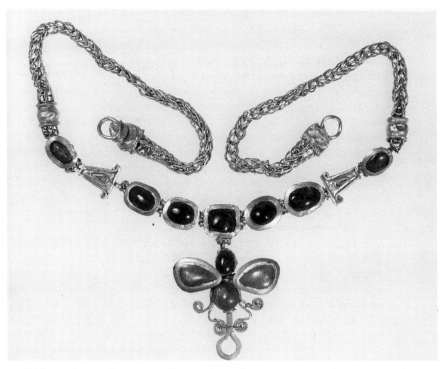

9 Gold, sapphire and garnet necklet with butterfly pendant. Formerly in the Castellani Collection, this necklet shows evidence of recent repairs and alterations, and its original form is uncertain. The clumsy loop extending below the butterfly, for instance, is not original. Components mainly 1st century AD. British Museum, BMCJ 2746.

1910 and 1925, but his approach was more stylistic than scientific. One of the best catalogues of ancient jewellery ever published, from the point of view of combining history with technical information, was the 1924 catalogue of the New York Historical Society's collection of Egyptian goldwork, by Caroline Ransome Williams. The technical information and replication experiments were carried out by John Heins, a metalcraft teacher who worked with gold and silver. This catalogue provides some of the earliest published microphotographs illustrating the technology of ancient goldwork.

Magnification

The purpose of examining jewellery under magnification is to reveal details of form, material or construction which are invisible or not readily visible to the naked eye. The question automatically arises as to whether ancient craftsmen used any form of magnification. The subject, and possible examples, are hotly debated. By the beginning of our era the magnifying effect of a water droplet, a near-spherical glass container or a suitably polished crystal must have been noted; certainly the use of a lens-like object as a burning-glass was known. However, it seems unlikely that the effect was put to much practical use. Such a startling and useful invention would surely not go so unremarked by classical writers, who took delight in the wonders of science and the natural world. Lucretius, for example, discusses the optics of mirrors in detail, but makes no

mention of magnification. Magnifiers are not used by native goldsmiths in many parts of the world today, even for the finest work.

Assuming magnifiers were not generally used by ancient goldsmiths, it is evident that if we look at an ancient object today at successively greater magnifications, we soon see details that were never seen, or intended to be seen, by the original owner. At only 10× magnification we will see features of which even the goldsmith would have been ignorant. These obvious points are worth bearing in mind, particularly if we are tempted to make aesthetic judgements on the basis of microscopic examination. An inexperienced person let loose on a microscope often reads too much deliberate human agency or design into minuscule details. For an idea of scale, we can assume that some of the platinoid inclusions in ancient gold (fig. 10) and the spiral 'seam' lines on some wires (fig. 11) were visible to the goldsmith and probably to his more observant clients. The Roman author Pliny implies that small inclusions and flaws in gemstones were noted. On the other hand, it is curious but likely that the details of some of the most diminutive engraved gems were not readily visible to their owners. For the goldsmith or gem-engraver, short-sightedness would have aided his ability to work on a minute scale. In the second century AD, Clement of Alexandria noted that perfect sight was epitomised by the gem-engraver – but we might wonder what he meant by perfect.

Examination of jewellery at various magnifications is the best and often the only means by which we can gain an understanding of the construction of the object. We can identify the type of techniques used in its production and gain an insight into the *modus operandi* of the original goldsmith. Today we have various methods of magnification to examine jewellery. The simplest is a relatively inexpensive folding pocket lens with 10x magnification. This is the basic equipment of all jewellers and gemmologists and should be considered mandatory for all archaeologists and art historians. A Sherlock Holmes-type hand magnifier is next to useless, although some antique dealers flourish one to impress clients. A watchmaker's loupe, which is held in the eye, is really only of value when both hands are needed and no microscope is available – for example, when taking samples in the field.

Examination of jewellery with a 10× pocket lens will usually provide a good idea of its condition, construction and material. This type of lens is held close to the eye, and the object an inch or two further away. In practice, the hand with the lens is held against the cheek and in contact with the hand holding the object. This stabilisation facilitates a detailed examination.

The next stage up is a stereoscopic or binocular microscope. This is such a vital piece of equipment that it is remarkable that some jewellery historians and even some museum departments do not have ready access to one. Ideally the microscope should provide various magnifications, either in a series of steps or as a continuous zoom. Each microscope should have a maximum magnification of at least 15x (as in fig. 11) and an ideal range for most work is probably between about 10× and 45×. Good lighting is very important. Various fibre-optic illumination methods are ideal; a nearby desk lamp is rarely acceptable. Ideally the microscope should also have facilities for photography. Microscopes vary considerably in price and even some of the least expensive ones are perfectly suitable for general work.

For examinations at much higher magnifications there are two main options. First there is the traditional optical microscope which can give useful magnifica-

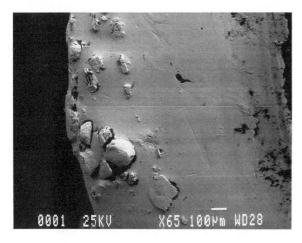

10 (*above*) Scanning electron microscope view of the platinum-metal inclusions visible on the surface of a Roman gold ring.

11 (*right*) Optical microscope view of a wire link from a Roman necklet, showing the spiral 'seam' characteristic of much ancient wire. About 20× magnification.

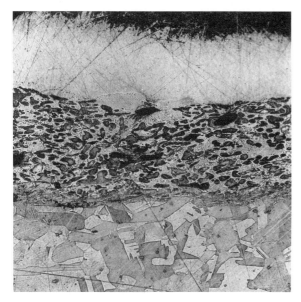

12 (*above*) This view through a metallurgical microscope shows a section through a Roman silver-plated coin. We can see the silver surface layer (top), the copper-alloy interior (bottom) and the silver/copper-alloy solder that joins them. Polishing and etching the section has revealed the crystal structures of the copper alloy and solder in great detail.

13 (*above*) Fragments of flax threading fibre from the suspension hole of a Middle Kingdom Egyptian electrum hawk pendant. As seen through a polarising microscope with slightly uncrossed polars. Aroclor® mount.

tion up to about 1000× or so. Second there is the scanning electron microscope and its variants. With the optical microscope there is always a problem with depth of field and thus the examination of three-dimensional features is severely limited. Today the optical microscope at magnifications over about 100× is really only used for the study of prepared specimens. For the jewellery historian this would include the study of polished metal samples with a reflected light or metallurgical microscope (fig. **12**), or the examination of non-metallic substances – such as corrosion products, threading fibres and filling materials – by transmitted light, usually with a polarising microscope (fig. **13**).

In general, higher power examinations are most usually undertaken today with a scanning electron microscope. This uses a beam of electrons rather than a beam of light and has the advantage of providing a great depth of field – as can be seen in scanning electron microphotographs of inclusions, filigree work and granulation (figs. **10** and **37**). Clear images can be obtained at up to 1000× or more. Another advantage of the scanning electron microscope is that it often has intrinsic facilities for analysis (these will be discussed below). The greatest drawback to the equipment is its capital and running costs.

Other advanced types of magnification at very high levels – providing resolution at almost the level of the individual atom – are coming into use and will eventually play an important part in archaeology. It is hard to see how such great magnification will aid studies of ancient jewellery techniques, but it is likely that there will be revolutionary studies of minute changes in materials, perhaps even gold alloys, over long periods of time.

Analysis

The purpose of analysis, in the sense that the word is used here, is to identify the materials from which an object or component is made. There are numerous techniques of analysis available and the choice will depend on the nature of the object and the type of information sought, as well as the cost and availability of the laboratory equipment and the type of sample obtainable.

The bewildering variety of analytical methods is matched by a similarly bewildering variety of materials which might need to be analysed. This is true even in the limited field of jewellery history. For example, a single gold ornament might include a gold alloy with a variety of major and trace elements present. Inset materials might range from a variety of organic and mineral gem species to glazes and enamel. In addition there can be surface patination products, adhering soils or other encrustations from burial, trapped fibres, and organic or other backing and filling substances.

Analysis is not some magical panacea for problems of authenticity or origin. Before embarking on analysis – whether a single analysis or a whole programme – it is important to enquire as to the type of results that can be obtained and how these will be relevant to the archaeologist or art historian.

Until the early part of this century, the only method of detailed analysis was destructive chemical analysis. A sample of the object would be removed, carefully weighed and then submitted to a series of chemical reactions and further weighings. The result would be a list of the elements present and their relative abundance. Chemical analysis of gold and silver jewellery dates back well over a century. For example, chemical analyses of early Irish gold ornaments were published by J. W. Mallet in 1853. Heinrich Schliemann published analyses of

some Mycenaean gold in 1878 and of some Trojan gold a few years later. At the beginning of this century the French chemist M. Berthelot published various studies of the composition of early Egyptian gold objects.

Some early analyses were far from precise, but there are notable exceptions. For example, a Bronze Age Irish sheet-gold collar of crescent form – termed a lunula – was one of the objects analysed by J. W. Mallet in 1853 and was also recently included in a major analysis programme by emission spectroscopy carried out by Axel Hartmann in Stuttgart. Mallet's chemical analysis showed that the collar contained 88.64 per cent gold, 11.05 per cent silver and 0.12 per cent copper. Hartmann's analysis, published 117 years later, found 88.9 per cent gold, 11.0 per cent silver and 0.1 per cent copper – an astoundingly consistent result.

The need to take samples for chemical analysis often meets with resistance from some curators. Certainly there are horror stories from the recent past, such as the total destruction of over two thousand similar medieval silver coins by Luschin von Ebengreuth in order to obtain an average composition. On the other hand, for most modern analysis methods only small samples are required, if any. It is hard to understand why some archaeologists, quite happy to dig a trench through an Iron Age hill fort, are uncomfortable with the removal of an inconspicuous speck from an object. Clearly, an analysis is worthless if the sample used is not representative of the whole object. Gold alloys are usually fairly homogeneous and minute samples can be used, but copper alloys in particular can be inhomogeneous, and care must be taken in sampling and interpreting the analytical results.

Almost any property of a substance can be used as a basis for determining its nature. A variety of methods of analysis are used for examining ancient jewellery today and a few common ones are described below. As noted in chapter 1, there is no scientific means of dating precious metals. However, analysis can quite often reveal a fake on the basis of its composition.

Since antiquity, the colour of gold has been taken as a judge of its purity. This can be quantified more accurately by making a rubbing of the gold on a hard black surface, a 'touch stone', and then comparing this mark to those made by pieces of gold of known purity. For a more accurate determination, acid is placed across the gold streaks on the touch stone and the speed and nature of their dissolution can be compared. The use of the touch stone (without acid) dates back into prehistory – some ancient examples that still retain gold streaks have survived – but the process finds minimal use today in archaeology, although it is still employed by some dealers and clandestine excavators.

Another long-lived method of analysis for gold is specific gravity. The specific gravity of a material is the weight of a given volume of the material as compared with the weight of an equal volume of water. Archimedes made his celebrated bath-time discovery of specific gravity and employed the technique to determine the purity of a gold crown. Essentially, pure gold will weigh more than a similar volume of gold that has been debased with silver or copper. Accurate weighing equipment now allows very precise specific gravity determinations. However, the method cannot determine the relative quantities of copper or silver in the gold. The object being tested must also be solid and without any parts of a different material. Specific gravity determinations have therefore proved most useful with gold coins.

In analysis by X-ray fluorescence spectroscopy (often shortened to XRF) a small area on the object or sample is irradiated with a beam of X-rays. The atoms

of the sample re-emit X-rays, the wavelength and intensity of which relate to the nature of those atoms and their relative abundance. XRF has been used over the years to provide numerous analyses of gold and other metal objects and has the advantages of being relatively quick, easy and cheap. Another form of X-ray fluorescence analysis can be combined with a scanning electron microscope. Here, a narrow beam of electrons is directed at the area to be analysed. This excites the atoms and, again, provides an emission of X-rays. This type of analysis, sometimes called the electron-probe microanalyser, can provide good analyses of minute samples or of inclusions or compositional variations within samples. The study of platinoid and other inclusions in goldwork and the examination of solders have been greatly helped by microprobe analysis of this type.

In general, X-ray fluorescence methods analyse the surface; if this is likely to be different in composition from the interior, the area to be analysed must be abraded or otherwise treated to reveal the underlying material. Nevertheless, X-ray fluorescence is usually considered a non-destructive technique although, of course, it can be used on a sample rather than the whole object if there are good reasons for doing this. With most modern equipment, a computer program collates the measurements and interprets the results. Electron-microprobe analysis is not suitable when information is sought about elements present in small traces.

In recent years another form of analysis has come into use. This is termed PIXE, which stands for proton-induced X-ray emission. It is somewhat similar to XRF except that, as the name suggests, protons are used to irradiate the object. Since the penetration into the object is deeper, the need for surface abrasion or other preparation is reduced. Ancient gold jewellery analysed by PIXE in recent years includes objects from the magnificent Eauze Treasure found in France in 1985. This late third-century AD treasure included coins and beautiful gold rings, earrings and necklets. Among the latter is one of the few surviving Roman sapphire-set ornaments from Western Europe.

Atomic absorption spectroscopy (AAS) has sometimes been used in the analysis of jewellery. However, it is more frequently used on copper alloys or silver than on gold because samples need to be taken. In AAS the sample is dissolved in an acid solution which is then vaporised. The absorption of light of different wavelengths when passed through this vapour allows the identification and quantification of the elements sought. AAS is very sensitive and can usually detect trace elements with far more precision than XRF. ICP (inductively coupled plasma) analysis is also coming into use for archaeological metals. Again, a minute sample needs to be dissolved in acid, but the process allows the accurate determination of trace elements.

Numerous other analytical methods have found some use in archaeology and many of these have been applied to jewellery. Laser-induced ion mass spectroscopy, sometimes called the laser microprobe, uses a laser to burn a minute pit on the sample and then analyses the ions released. Neutron activation analysis (NAA), which measures the gamma radiation from a sample artificially made radioactive, provides very precise results for trace elements present as one part per million or less. NAA requires only the minutest of samples – such as a merest rubbing of the object on a quartz rod – and is thus very suitable for archaeological metals. NAA has been used a great deal for the analysis of silver, particularly coins. Disadvantages of NAA include its high cost and its inability to detect lead – an important component in many silver and copper alloys.

Infrared absorption spectroscopy is useful for the identification of organic remains. For example, this process has been used to characterise ancient amber. Minerals, including gemstones as well as other crystalline substances such as corrosion products, can be examined by means of X-ray diffraction (XRD). In this technique X-rays are aimed through a powdered sample which bends or 'diffracts' the rays so that they form a pattern on a photographic film which characterises the sample. Only a minute sample is needed.

Some analytical techniques can be used to determine the relative amounts of different isotopes of the same element (that is, two or more forms that differ only in their number of neutrons). The ratio of the number of atoms of these different isotopes of an element will depend on the geochemistry of its origin. Since this can vary from region to region, isotope ratios provide one way of attempting to 'fingerprint' a source. The widest use of isotope studies for ancient jewellery has been that of lead isotopes. Ancient silver typically contains a small percentage of lead and this is enough to allow a determination of the isotope ratios and thus source correlation. There are other potential uses for isotope analysis in the field of jewellery history. These include the use of sulphur isotopes in the characteris- ation of lapis lazuli, which partly consists of a sulphide mineral, and perhaps sulphur itself, which was a common filling material in much Roman sheet-gold jewellery.

The results of a single analysis will seldom be of more than passing interest unless it indicates forgery. Only after a sufficiently large body of analyses has been carried out and published can any patterns of chronology or geography be identified. A necessary foundation is a large database of analyses of similar objects of known date. For precious metals, coinage has been an ideal choice of object. Coins can be dated accurately and, in some cases, provenanced on the basis of mint marks. Gold and silver coins were probably a major source of precious metals for the day-to-day goldsmithing and silversmithing industries from the mid first millennium onwards.

One such study was based on analyses of Dark Age European gold coinage, which shows a debasement between the late sixth and late seventh centuries AD from over 90 per cent pure gold down to under 40 per cent. The gold alloys used for Anglo-Saxon jewellery over the same period reveal the same general de- basement. Thus Anglo-Saxon and some other Dark Age jewellery can now be tentatively dated on the basis of its composition. The comparison of analyses of Sasanian silver coinage with contemporary silver vessels has provided facts about the trace elements which, in turn, can provide some chronological and regional information and help to weed out fakes.

A large number of analyses of Roman and early Byzantine gold coins have now been published, but there is not always obvious correlation with contem- porary jewellery alloys. For example, some Roman goldwork is as pure as the coins, but much of it is debased. We can note here that analysis of base-metal ornaments can also provide useful information – for example, the composition of many Roman copper-alloy ornaments reflects that of the contemporary coinage.

Other methods of examination

Metallurgy is the study of metals. A variety of testing processes are used in- cluding techniques to quantify hardness, brittleness and other mechanical properties. The branch of metallurgy most used in jewellery studies is metallo-

graphy, the study of the microstructure of metals. Metals are crystalline, that is, they are composed of minute crystals the shape, structure and size of which relate to the composition of the metal and the nature of the processes used to form it. The study of the internal structure of a metal is typically carried out by polishing a very flat surface on the metal, etching this by chemical or other means, and then by examining this surface with a microscope (fig. **12**). One of the earliest metallurgists to study ancient precious metals in this way was Major H. Garland, Lawrence of Arabia's explosives expert, but sadly he died before his research could be fully published. Metallography of ancient gold has been largely superseded by the common use of the scanning electron microscope to study, for example, solder seams in cross section. Perhaps the main use of metallography for gold jewellery in recent times has been the study of the various copper-gold and platinum-gold ornaments from Central and South America.

Gemmology is the branch of mineralogy that deals with the gem materials which, for practical reasons, also include glass and other substances used to imitate gemstones. The study of a gemstone will usually permit its ready identification and in some cases can provide an idea as to its origin. Descriptions such as 'red stone' in a museum catalogue or excavation report are seldom excusable today, although it must be admitted that it is better to say 'red stone' than make an inaccurate guess.

The choice of gem materials used in ancient jewellery can have an important bearing on its origin and age. We must take into consideration the changing fashions for gemstones, the geographical location of the mines or sources and the political and economic factors that influenced trade. For example, an ornament set with emeralds and pearls is unlikely to date to before about 200 BC, while a first-century AD Roman ring set with a garnet is more likely to be from Syria or the Levant than from Asia Minor.

The minute inclusions within a gemstone can sometimes be indicative of a certain origin. For example, several so-called Roman emerald intaglios have been revealed as fakes because the stones themselves can be proved to be from South American mines or even made from modern synthetic rather than natural emeralds.

— 3 —

The Materials

The production of jewellery, like any object, involved working the available raw materials to form the desired end product. Of course, there are a vast number of factors affecting the final appearance of the finished ornament – ranging from the goldsmith's skill to the customer's economic standing. In the past the general tendency has been for the nature and sources of the raw materials to be studied by the scientist, while the form and style of the finished object were more in the realm of the archaeologist or art historian. Today it is beginning to be realised that both approaches must be used in tandem. Filigree work, for example, can be examined in terms of the methods by which the wire was made and soldered, or in terms of the patterns in which the wires were arranged. Ideally no one should attempt to study one without considering the other.

An important factor in jewellery production is the interrelationship between craftsman, customer and the supply of raw materials. The choice of materials can throw light on a great variety of factors ranging from international political impediments to trading patterns to the social standing of the customer. In antiquity the customer would often provide the raw materials – as true for the local village tinker as for the temple workshop.

The raw materials used for jewellery over the centuries have included almost every natural and artificial substance known to humanity. Of these, a handful have found pre-eminence and will be discussed here. The identification and study of gem materials used in antiquity allow a better understanding of the jewellery itself and also provide archaeologists with evidence for ancient trading patterns. The choice of materials in antiquity reflected not just availability, but also ease of working and intended use. Jewellery should be strong enough to stand up to reasonable wear. For example, soft stones were too easily rubbed or broken; harder stones, although more durable and capable of a finer polish, could only be shaped with difficulty, if at all. For such reasons the majority of the gemstones used throughout the Bronze and Iron Ages were of about the same hardness as sand – the most readily available abrasive for cutting and polishing.

In earliest times a wide variety of easily available materials served to make jewellery. These included pretty pebbles, shells, teeth and bones, and even

seeds, twigs and flowers. It is sobering to notice how such organic forms, favoured in the Stone Age, have been the basis of jewellery designs throughout history, whether translated into gold or silver, or more recently even diamond-studded ornaments.

With time, human nature decreed that the rarer the material the more desirable it became and so trade in ornamental substances grew up – sometimes over vast distances. Shiny nuggets of gold from river beds, native copper and perhaps some native silver were favoured because they could be beaten and cut into complex forms. Then, in turn, it was discovered that small pieces of metal could be melted together to form larger masses and that certain metals could be produced from ores.

Gold, silver and gemstones do not occur in the Old World with any uniformity, so the jewellery of this area was closely tied to the ever-increasing importance of trade and contacts. This led to an overall homogeneity in styles over much of the ancient Near East – the major exception being Egypt, whose traditional jewellery styles were only marginally influenced by its neighbours.

Gold

The primary jewellery metals in the ancient Old World were gold and silver. Platinum was unknown as such. Gold occurs as a native metal – that is, in its metallic form, bright and shiny and appealing to the most primitive prospector. In the simplest case it is retrieved as alluvial gold from the sands and gravels of rivers by uncomplicated separation techniques ranging from panning to larger-scale washing procedures. Gold is far heavier than the accompanying sand or gravel and remains in the pan or on a rough washing table when the associated river sands and other materials have been washed off. By sometime in the second millennium BC, gold was also being retrieved from primary deposits, from veins of gold in quartz rocks. There the process is far more laborious. The rocks must be crushed and then ground to a fine powder. This is then washed, like alluvial gold. Hard stone grinders are to be found at many ancient mining sites (fig. 14).

Gold sources are rare in Mesopotamia (modern Iraq) and Iran, and the peoples of these areas had to import from Arabia, Anatolia, Afghanistan and perhaps even India and eastern Europe. Egypt, on the other hand, had sources of gold close at hand – in the Eastern Desert and in Nubia (fig. 15). One of the

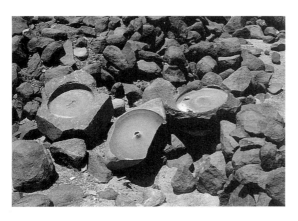

14 (*left*) Grinding stones in the vicinity of an ancient gold mine in the Eastern Desert of Egypt. These hand grinders, dating from between about 300 BC and 300 AD were used to grind the quartz rocks that contained the veins of gold. The powdered rock was then washed away to leave the heavier gold. Numerous ancient authors cite how captives, slaves and the persecuted were forced to work in the Egyptian gold mines.

15 (*opposite*) Map of the main gold-producing regions of the ancient world, and also showing the source of some of the more common gemstones.

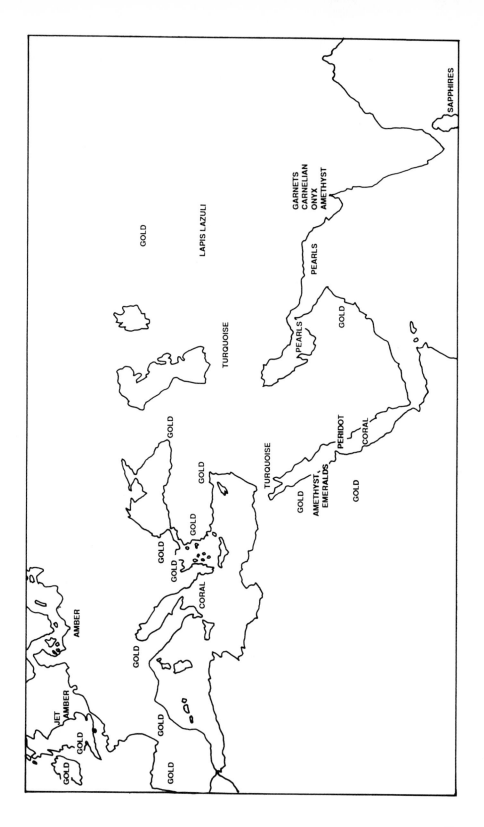

earliest surviving maps from the ancient world shows the whereabouts of the goldmines in the Eastern Desert of Egypt. This map, dating from *c*.1250 BC, is preserved in Turin. Recent research has identified the actual position of these mines and correlated the local geography with the features shown on the map. There are no such maps from prehistoric Europe, but, nevertheless, gold is fairly abundant, particularly in eastern Europe and the Balkans and much further to the west in Spain and Ireland.

Despite a commonly held view to the contrary, ancient goldwork is seldom made of pure gold. In nature, gold typically has an admixture of silver and copper, plus traces of a variety of other metals. The silver content of native gold can range from under one per cent up to 40 per cent or more; copper rarely occurs as more than about two per cent, although there are exceptions to this. As the proportion of silver in gold increases, so the colour becomes paler – changing from yellow to a greenish yellow and eventually greyish white. Gold with over about 25 per cent silver present has a distinct pale colour and is often termed electrum.

In earliest times gold was probably employed just as it was found, but by the mid-third millennium BC copper was sometimes added to both gold and silver, although the impetus for this is still uncertain. The addition of copper to gold reddens it and some Egyptian signet rings of the late Eighteenth Dynasty contain 50 per cent or more copper, which gave them an attractive reddish colour. The addition of silver to gold was also carried out for aesthetic or economic reasons.

The refining of gold, to remove any silver and copper content, was probably understood by the mid-second millennium BC, but does not appear to have come into general use until about a thousand years later. Possibly the introduction of coinage at about this time demanded a greater degree of reproducible stan- dardisation. The introduction of refining does not mean that from then on all gold coinage and jewellery was of pure gold; gold was debased with silver, and to a lesser extent with copper.

Refining technology meant that gold of a very high purity could be attained in Hellenistic and Roman times, and much of the coinage and some jewellery is almost pure gold. However, for practical or economic (even fraudulent) reasons, gold was also debased. It is probable that after the introduction of precious metal coinage, in the mid-first millennium BC, coinage became a common, if not the commonest, source of precious metal for the person in the street and thus for jewellers and their patrons. Roman gold coinage is usually of extremely high purity – over 99 per cent – but the economic problems of the third century AD led to some debasement and Roman gold coins of this period can be under 90 per cent pure. Gold jewellery was far more often debased than coinage and Hellenistic and Roman jewellery can range from 75 to nearly 100 per cent. The finer quality work is not necessarily of the highest purity. It is unknown whether the de- basement was carried out by the state or individual goldsmiths and, in either case, whether the customer was aware of it. Recent analysis has suggested that there might be some chronological and geographical debasement trends in the Hellenistic and Eastern Roman empires. Towards the end of the third century AD there was again an improvement in coinage purity and this was retained throughout the early Byzantine period – although the average was still slightly lower than that of the early Roman period. Byzantine gold jewellery varies in purity, but around 92–3 per cent is quite common and a deliberate standard, perhaps like our modern 22 carat (91.67 per cent), might have been intended. The

Byzantine gold coin, the solidus, was divided in 24 *keratia*. This is the origin of our carat standard, whereby gold purity is expressed as parts per 24: that is, 18-carat gold is 18/24 gold and thus 75 per cent pure.

Certain categories of ancient gold, including some prehistoric European gold, are considerably debased but, in general, we should keep some perspective with regard to the purity of the gold used in antiquity. Hellenistic, Roman and Byzantine gold jewellery seldom if ever drops below 75 per cent pure – the equivalent of the 18-carat gold that we think of as high quality. Most ancient goldwork is over 85 per cent pure, that is, over 20 carat. The low levels usual today, the 9-carat (37.5 per cent) gold of Britain and the 14-carat (58.3 per cent) gold of the United States, represent a degree of debasement not even dreamt of by the most devious of classical goldsmiths.

A variety of graphical devices are used today to plot gold purities. Ordinary two-dimensional graphs can be used to show the relative amounts of two components or of particular relationships, such as the copper/silver ratio compared to gold purity. When there are three predominant constituents – such as the gold, silver and copper of most ancient goldwork – we can use the so-called ternary diagram. This allows us to plot in two dimensions the relative abundance of three components. The ternary diagram is traditionally shown as an equilateral triangle. The apexes represent the pure metals and any combination of these can be represented by a point within the triangle (fig. **16**). A large number of analyses can be plotted on a single ternary graph and thus any patterns or groupings can be easily discerned. From specialised ternary plots of gold alloys we can read off various properties including their melting temperatures and an idea of their colours. Other plotting methods, including versions of the ternary graph and specialist statistical charts, have been developed to illustrate trace-element contents of gold alloys.

The relative proportions of gold, silver and copper in a gold alloy seldom provide much information about its origin, although certain alloy types can be typical of certain periods. The determination of gold sources is more feasible – at least in theory – when the trace elements in the gold are considered. Native gold can contain small amounts of numerous trace elements including tin, iron,

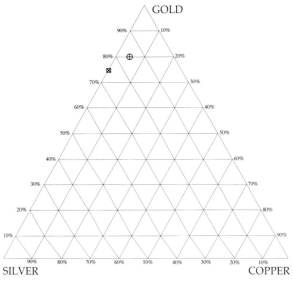

16 Ternary diagram as used to plot the gold, silver and copper content of gold alloys. Pure gold lies at the top apex, pure silver at the lower left and pure copper at the lower right. Assuming that the content of gold + silver + copper amounts to approximately 100%, any composition can be represented by a point on or within the triangle. For example, an alloy of 75% gold with 25% silver and no copper would be shown by the x in the small square in the diagram. An alloy with 80% gold, 15% silver and 5% copper is marked by the cross in the small circle.

31

platinum and other members of the platinum family of metals (these are often small silver-grey grains of osmium, ruthenium and iridium, which remain undissolved in the gold as small specks – some are even visible to the naked eye; see fig. **10**). Recent research has found minute inclusions that seem to be of some type of tin mineral in examples of Hellenistic period gold. Most trace elements are not present as inclusions, but are homogeneously distributed in the gold – often as under 0.01 per cent – and only detected by accurate analytical techniques (see pages 22–5). The presence of trace elements can provide useful information about the source, refining and alloying of ancient goldwork, but such information is limited because gold was commonly traded and recycled. Trace elements have been of use in categorising prehistoric European gold and might eventually help with the characterisation of coins from individual classical mints. For gold of the main civilisations in the Mediterranean, from the Bronze Age onwards, trace-element analyses provide little information apart from some help in the identification of forgeries.

A few less usual alloys and colour effects are occasionally seen. For example, some New Kingdom Egyptian gold, seemingly only that from royal burials, has a rose-pink to purplish surface. This was intentional and was probably produced by the addition of some iron compound to the gold. Clearly, such surfaces should be retained during conservation treatment.

In general, the cleaning of any gold with an abrasive or polish should be avoided, as gold easily scratches. Acid cleaning is generally too harsh and is unnecessary. However, a very weak acid can be used to remove the calcite encrustations found on some ancient gold – such as some jewellery from Asia Minor. Some gold jewellery has a reddish surface caused by thin layers of clay, iron or copper oxides, or even gold sulphide. These surface additions, though an effect of age and not intentional, are usually retained unless they are particularly disfiguring.

Ancient gold with a marked silver content will be pale in colour. This could be disguised by surface treatments which etch the outermost silver to leave a purer gold surface. Various combinations of heat and simple chemicals have this effect. Although these procedures were probably common in antiquity, it is difficult to distinguish such artificial treatment from the surface-leaching effects of burial.

When gold has a substantial silver or copper content it can also be subject to internal decay – in extreme cases it can be crumbled like a biscuit. This embrittlement is more typical of silver, and an apparently solid and pristine-looking silver ring can shatter into fragments if dropped.

Silver

Silver very rarely occurs as a native metal and would generally have been obtained from smelting a mineral ore, even though silver might only be present in minute amounts. Such ores include galena (PbS), ceragyrite (AgCl), and more complex ores such as the jarositic ores of Rio Tinto in Spain. However, some gold mines also contain aurian silver, a natural alloy of silver with a few per cent of gold present. Such aurian silver was used side by side with other silver in early Egypt where, it is believed, aurian silver was found in some of the Nubian gold mines. There is evidence for the exploitation of silver ores by the early third millennium BC.

As with the other metals used in antiquity, silver shows a great variety of

compositions. High-purity silver, that is with over 95 per cent silver, is typical of much Roman, Sasanian and Byzantine silver, but also occurs much earlier – for example, in some Phoenician jewellery from the mid-first millennium BC. Even in the early second millennium BC some exceptionally high-purity silver can be found. Whatever the type of silver (native, aurian or smelted from most silver ores) it rarely contains more than about 1.5 per cent copper; the frequent presence of copper in excess of this amount in silver objects of all periods – as far back as the early Bronze Age – points to deliberate addition. Silver was sometimes debased with copper to a considerable extent. This is true of much Roman-period coinage and even some Roman jewellery was made of silver debased with up to 50 per cent or so copper. These alloys are highly susceptible to corrosion.

Ancient silver typically contains traces of lead, gold (usually under one per cent), bismuth and other metals. The presence of these trace elements and their relative proportions can be useful in determining the origin and refining practices employed and in resolving problems of authenticity. For example, the gold and iridium levels in Sasanian silver have been subjected to detailed examination and the study of the ratio of lead isotopes in other silver has been a useful indication of ore sources.

Silver jewellery has not survived from antiquity in great abundance. In early periods this might sometimes be explained by the rarity of raw materials. In Egypt, for example, silver was originally more valuable than gold and for a long time was more highly valued in Egypt than elsewhere in the Mediterranean world. There are important groups of silver jewellery – such as the recently found Snettisham hoard of Roman silver jewellery – but such finds are not common. The rarity of Hellenistic and Roman silver jewellery, compared to gold, cannot be blamed entirely on scarcity of materials or on the greater susceptibility of silver to corrosion over long periods of time. Literary evidence from the Roman period suggests that there were injunctions against the use of silver coinage for jewellery. Rings (fig. **17**) and bracelets are the commonest silver ornaments, while earrings are rare.

Base metals

Iron was used to produce some ornaments – mainly finger rings (fig. **17**) – but the most common base metals for jewellery in antiquity were alloys of copper. Figure

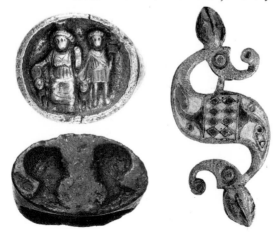

17 Jewellery was made from a variety of metals. Shown here are a Roman silver ring from Turkey (*top left*) with a design in relief showing a seated Kybele flanked by a youth; a copper-alloy 'dragonesque' brooch of s-form, with white and blue enamelled decoration found in Britain; and a Roman iron ring (*bottom left*), the oval bezel carved with confronted male and female heads, from Turkey. All three date to around AD 100. British Museum, BMCR 1130, P&RB, BMCR 1479.

18 Two British Bronze Age 'Sussex loop' bracelets – a type found only in the southern English county of Sussex. Hammered bronze. 12th century BC. British Museum, PRB 53.4–12.16, 17.

18 shows a pair of bracelets of *c.*1200 BC. These are of the so-called 'Sussex loop' type which are only known from Sussex in southern England. For most of antiquity copper-tin (bronze) alloys were favoured, but by the early Roman period copper alloys with added zinc began to be used. This alloy, known as orichalcum, had a gold-like appearance which undoubtedly prompted its use. Indeed, newly made orichalcum jewellery is sometimes indistinguishable from gold by sight alone. It is important to bear this in mind when looking at corroded and encrusted copper-alloy ornaments as excavated today. Many of the gold imitations patented during the nineteenth century for use in the costume jewellery industry were similar copper-zinc alloys.

Copper-alloy jewellery, particularly rings and brooches, could be gilded or decorated in other ways. For technical reasons, pure copper is easier to gild than copper alloys, and it is probable that most of the Roman copper rings now in collections were once gilded. In early times copper alloys were gilded by simply folding or sticking gold foil over the object. During the second millennium BC silver and copper alloys were gilded by means of a combination of heat and pressure. In at least some cases the sheet metal was gilded before it was fabricated into the desired object. By Roman times mercury amalgam gilding had come into use and provided a durable gilded layer. Mercury gilding relies on the property of mercury to dissolve gold to form a pasty amalgam. A gold-mercury amalgam can be spread over silver or copper alloys, or gold foil can be applied over a layer of mercury. In the former process, traditionally termed 'fire gilding', the mercury is removed by heating (although traces remain and can be detected by analysis).

In Roman times copper alloys were often coated with a thin layer of tin which gave a bright silver appearance – surviving examples are quite frequently misidentified as being silver-plated. Iron Age European and Roman copper-alloy ornaments were often enamelled (fig. **17**).

Iron jewellery is generally limited to bracelets and rings; Hellenistic and Roman iron rings are often of far better quality, and thus presumably more desirable, than contemporary copper-alloy ones. Iron jewellery stays bright and unrusted when worn, and even today ancient iron rings can be mistaken for silver when cleaned. Iron signets could be used to impress lead seals, whereas gold, silver or copper-alloy rings could be ruined by the molten lead.

34

A combination of metals was sometimes used in ancient jewellery – for example, gold inlays or overlays on silver. Some metals were chosen for their mechanical properties; some delicate Phoenician and Etruscan goldwork contains silver rivets or backings for increased strength (for example, fig. **38**). Copper-alloy rivets and hinge-pins are common on some late Roman and Byzantine gold ornaments for the same reason.

Gemstones

The stones used in jewellery – on their own as beads or pendants, or set in metal – range right across the mineral kingdom, from the simple, soft pendants of graphite that have been found in Bronze Age contexts in Syria, to the diamond crystals in some late Roman rings (fig. **21**). Incidentally, both graphite and diamond are chemically carbon but in totally different forms. In the Bronze and early Iron Age in Europe gold jewellery was rarely set with coloured stones, but in Egypt and Western Asia brightly coloured stones were very popular. Royal blue lapis lazuli – traded from Afghanistan – and reddish-orange carnelian were particularly favoured, and numerous other stones such as malachite, rock crystal, turquoise, green feldspar and amethyst were sometimes employed. In general, in early times coloured stones were used like blocks of pigment. This is particularly noticeable in Egyptian jewellery where the opaque, coloured stones set in figural jewellery produce icon-like forms (fig. **19**).

From about the beginning of the Hellenistic period, and probably connected with Alexander the Great's victories in the East, brighter, transparent stones became more favoured. For example, the finer bright-red garnets that came into vogue in Hellenistic times probably originated in India. The fashion for garnets largely died out in early Roman times except in Syria and the Levant – they are rare in early Roman Egypt, Cyprus, Asia Minor and even Italy. Garnets, the colour of wine and blood, were probably associated with Dionysos.

Emeralds also became popular in the mid-Hellenistic period and were highly favoured in Roman and early Byzantine times. This green stone was to be found

19 Front view of a gold pectoral from el-Riqqa in Egypt, set with lapis lazuli, carnelian and turquoise. The pectoral is in the characteristic icon-like form of much Egyptian jewellery and uses inlaid stones almost as blocks of pigment. At the top the design takes the form of a sun disc flanked by the eyes of Horus, below the sun disc is a sceptre, and on each side unidentified birds stand on hieroglyphic signs for gold. The sides of the sceptre are in the form of papyrus rushes. Middle Kingdom, *c.* 1900 BC. Manchester Museum, 596.

in the arid, mountainous Eastern Desert of Egypt. By modern standards, these emeralds are badly flawed and cloudy, but they were prized in antiquity, and Roman-period emerald-set goldwork has been found as far afield as Britain. In Hellenistic times the emeralds were usually cut into spherical beads or cabochons, but in the Roman period it was normal to leave them in their natural crystal form as hexagonal prisms, a shape that survived into Byzantine times (fig. **20**).

Diamonds, sapphires, aquamarines, peridots, citrines and amethysts also add colour and brilliancy to Roman jewellery (fig. **21**). The handful of Roman diamond-set rings that have survived are set with diamonds in their natural tetrahedral crystal form – like two four-sided pyramids base to base (fig. **21**). Recent research has shown that chips of diamond were being used by gem cutters by the Hellenistic period (fig. **22**), but ancient diamond-set jewellery is limited to a number of rings from the Eastern Roman Empire dating from the late third or

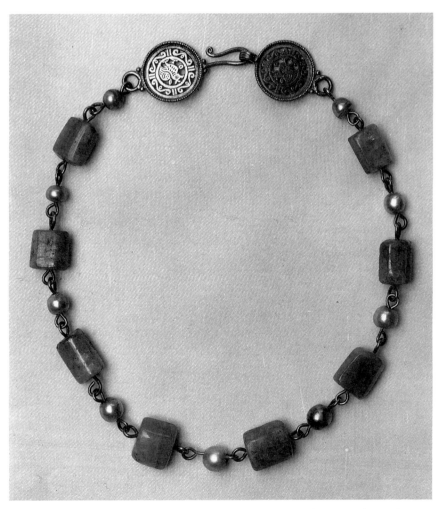

20 Gold necklet with emeralds and pearls. The emeralds retain their natural crystal shape. Egypt, 6th-7th century AD. Formerly in the J. Pierpont Morgan Collection, now Metropolitan Museum of Art, New York, 17.190.153.

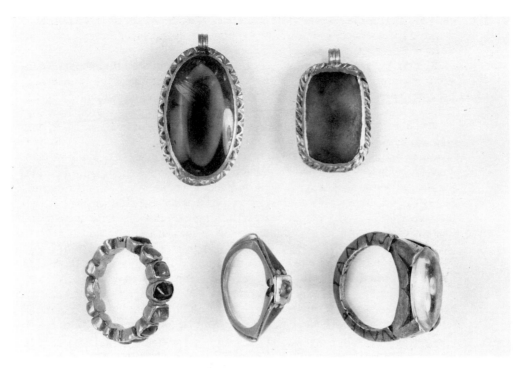

21 (*above*) Roman gem-set jewellery. Top: gold pendants set with a citrine (*left*) and a peridot (*right*), both found in France. Bottom (*left to right*): gold ring with emeralds, garnets and sapphires; angular gold ring with a diamond; gold ring with an aquamarine. British Museum, GR 1924. 5–14.7, 9, BMCR 858, BMCR 787, GR 1924. 5–14.3.

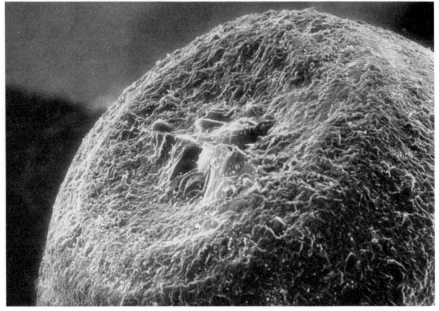

22 Scanning electron microphotograph of a silicon rubber impression of a drill hole in a rock-crystal bead. The shape of the perforation is typical of that produced by a diamond-tipped drill.

early fourth century AD. The cutting and polishing of diamonds was a development of the medieval period, when diamonds began to become popular in Europe.

The occasional Hellenistic sapphire intaglio is mentioned in catalogues, but extant sapphires set in original gold mounts are typically of the Roman and Byzantine periods. Sometimes they are combined with emeralds and garnets (fig. 21). Most of the sapphires are of the pale blue associated with the Ceylon deposits, but the darker sapphire beads, usually of flattened lentoid shape, which are mainly found in second- and third-century AD Roman jewellery might have had a different source. Direct sea trade between the Red Sea and Ceylon developed during the Roman period and gemstones were an important part of the eastern sea trade – along with spices and other exotic goods. In at least some cases, precious imports were subject to a 25 per cent tax when they finally entered the Roman Empire. This helped redress the huge export of gold from the Empire that financed the overseas purchases – an economic drain to which several Roman writers refer.

The nature and quality of the gemstones used in antiquity can differ considerably from those favoured today. The commonest ancient gemstones, namely carnelian, lapis lazuli and garnet, are today reckoned semi-precious at best. The stones we consider more precious tend to be harder and thus more difficult to work. As we have seen, emeralds and sapphires only came into use in the Hellenistic period. The ruby is one of the few gemstones popular today that was all but unknown in antiquity – presumably because the main source, in Burma, was outside the usual trade contacts of the Romans, and perhaps because garnet provided a similarly coloured but more easily worked alternative.

In some cases the absence of a stone in jewellery of certain periods or certain areas must reflect international rivalries and thus trading limitations. For example, lapis lazuli was highly prized in early Egypt and Sumeria – enough for it to be traded all the way from its source in Afghanistan. However, once into the Hellenistic and Roman periods, lapis almost totally disappears from the Mediterranean world, and only in the early Byzantine period does it sporadically recur. Turquoise also has a chequered history. There were various sources of turquoise in the ancient world, including Sinai and Iran. In Egypt there was an early use of the stone – presumably from the Sinai mines. The pectoral in figure 19 includes inlays of turquoise as well as lapis lazuli and carnelian. The almost total lack of turquoise from the New Kingdom in Egypt must reflect the accidents of survival since contemporary inscriptions prove the extensive working of the mines. On the other hand, turquoise is strangely absent in early Sumerian jewellery – in a country neatly wedged between the Sinai and Iranian deposits. Turquoise is also unknown in Mediterranean Hellenistic jewellery and very scarce in Roman jewellery – although at these same periods it was very popular in Bactrian goldwork from Afghanistan.

Organic materials

Of the organic materials, amber (fossilised pine resin) was mainly a feature of the early European and classical world, and was more often used as beads and pendants than set in gold. Much the same is true of the black, coal-like mineral jet, although this found some use in goldwork in the Roman world. Coral was used for beads and pendants in various periods and places, but was seldom set in

gold. Coral and amber are among the few gem materials set in prehistoric European goldwork.

Pearls are almost unknown before the mid-Hellenistic period, but then became extremely popular, perhaps the most popular of Roman and early Byzantine gem materials (fig. **20**). Various Roman authors tell of women's ears weighed down by pearl earrings. Most of the pearls we see in Hellenistic and Roman jewellery probably came from the Persian Gulf and off the north-western coast of India; there is minimal evidence for their recovery from the Red Sea. Ancient pearls are typically drilled as beads, whether set in gold or not. In late Hellenistic and Roman times pearls were imitated in a variety of materials including polished mother-of-pearl and shell.

Glazed stones and glass

Various stones, including quartz and steatite, were being treated with a greeny-blue glaze by the beginning of the third millennium BC, and soon afterwards so-called faience came into use. This was a form of glazed fused quartz – most widely known for the myriad of blue faience tube or 'mummy' beads from Egypt.

Glass was mainly a mid-second millennium development. Glass was used alone for bracelets, rings, beads and pendants; inlaid in jewellery, such as much of Tutankhamun's spectacular goldwork; and as enamel – that is, applied to the surface of metal in a powdered state and then heated until the glass fused in place. Glass beads and inlays frequently imitate the colours and even shapes of gemstones – often with remarkable success. Glass imitations of the various banded agates are quite common, and in Roman times we often find green glass beads imitating the colour and hexagonal crystal shape of emeralds (some have fooled archaeologists to this day).

Enamel first occurred in Mycenaean goldwork of the mid to late second millennium BC and again in the early first millennium in Egyptian and Phoenician goldwork. Thereafter the technique became popular in Etruscan and Hellenistic

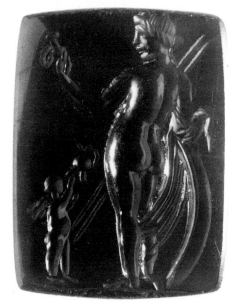

23 Large orange carnelian intaglio depicting Venus with a small figure of Cupid. Found in the Thetford Treasure, which dates to around AD 400, this stone is of earlier Roman date and has clearly been re-cut for reuse. The rough cutting of the top and bottom edges is in contrast with the finer workmanship of the rest of the stone. British Museum, P. 1981.2–1.41.

gold jewellery. In the second half of the first millennium BC, enamel was particularly popular in the Meroitic state in what is now the Sudan. Enamelled gold became rarer again in Roman times, but Roman copper-alloy jewellery is frequently enamelled (fig. **17**). Silver was seldom enamelled prior to early medieval times, probably because of a combination of adherence problems and differing relative coefficients of expansion. If the enamel and underlying metal contract at different rates during cooling, the enamel will fracture and become detached. Glass, including enamel, is very prone to decay and is often now in a very decomposed state if it remains at all. The Hellenistic goldwork in present-day collections retains only a hint of its original enamelled polychrome splendour.

Recycling

Precious materials have always been recycled. Stones were often reused and, in some cases, recut. Examples include intaglios and other seal-stones cut down to fit new mounts. The stone in figure **23** from the Thetford Treasure is a good example of this. Here an oval stone has been rather clumsily recut to a rectangular shape, presumably to fit into a new setting. Unless lost, gold will be continually remelted and reworked. Ancient goldwork sometimes shows signs of having been repaired or adapted in antiquity. The majority of the gold buried with the dead has long since been dug up and put back on to the market. There are records from ancient Egypt of the actual trials of tomb robbers, and the fine Middle Kingdom Egyptian pendant in figure **19** was found in a tomb on a mummy – together with the skeleton of an ancient grave robber who had been killed trying to retrieve it when the roof of the tomb collapsed. A modern wedding ring could easily contain atoms of the gold sacked from Troy or from the funerary paraphernalia of Ramesses the Great.

— 4 —

The Craft of the Jeweller

This book is mainly concerned with jewellery made from precious metals. Since even quite rudimentary metalwork requires some tools of copper or copper alloys, our history of jewellery technology must start around the beginning of the third millennium BC. By this period the dawning civilisations of Western Asia and Egypt were producing quite sophisticated jewellery in gold, silver, copper and a variety of coloured stones.

Craft processes have traditionally been trade secrets, handed down through families or via apprentices. Our knowledge of ancient goldsmithing techniques is seldom based on literary evidence, but relies mainly on a combination of microscopic examination of ancient goldwork and experiments to replicate its characteristics. There is some pictorial evidence, but this provides few insights. Examples of depictions of goldsmiths include the reliefs in the tomb of Petosiris in Egypt (fig. **24**), which date from around 300 BC; these show craftsmen manufacturing precious-metal vessels. From Pompeii there is the famous wall painting in which small cupids are shown in a goldsmith's workshop. The cupids are shown beating out the gold and engaged in delicate chasing or hammering, and working with a furnace, probably soldering. There is also a customer inspecting finished pieces. In other images depicting goldsmiths – on objects ranging from Palmyran tesserae to Roman tombstones – they are invariably shown with a hammer. This reflects the reality that hammering gold out into sheet form was the starting point for most ancient goldwork.

The majority of gold jewellery available in jewellers' shops in the developed countries today is made of cast gold or from a series of linked or soldered cast components. This was not true in antiquity, when cast-gold objects were rare; most of the gold jewellery produced in the ancient Mediterranean world and Western Asia was composed of sheet metal. The sheet-gold forms could be ornamented with inset stones, enamel, applied filigree work, granulation and a variety of other techniques.

Complexity of work varied greatly depending on time and place. In some instances intricacy of workmanship was inversely proportional to the amount of gold available in the society. The Etruscans, for example, had scanty access to gold and their jewellery is characterised by lightness and precision workmanship

on an incredibly minute scale. In other cases variations in the complexity (not necessarily skill) of workmanship reflects fashions or factors unknown to us. For example, much late Hellenistic goldwork is characteristically composed of numerous separate small elements – it is not unusual for a ring or earring to consist of several hundred minute components including granules and filigree wires. On the other hand, just a generation or so later one class of Roman goldwork, such as much of that from Pompeii, is characterised by the opposite assembly approach – a whole earring might be made from just one or two separate pieces of gold.

The examination of ancient jewellery reveals not only the general technological level prevalent at the time and place where it was made, but also shows us something of the individuality, skill and ingenuity of the craftsmen who made it. For example, much Hellenistic Greek filigree work is composed of finely spiral-beaded wire arranged in geometric and organic forms such as rosettes, spirals

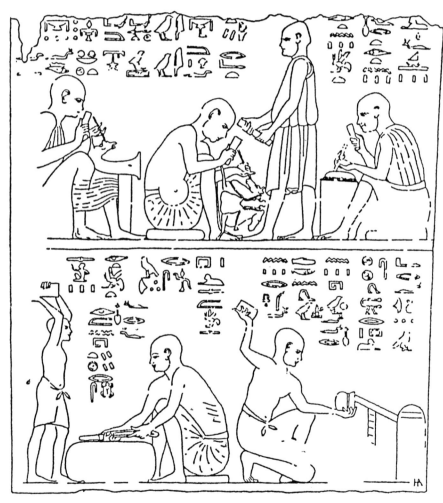

24 Detail from the carved decoration in the tomb of Petosiris in Egypt. The scenes show gold and silversmiths making vessels and other objects and are among the most detailed of surviving ancient representations of craftsmen. *c.* 300 BC.

and leaves. Some goldsmiths formed complex shapes with single intricately bent lengths of wire; others used many shorter lengths of wire. The overall effect is the same, and the differences are often only discernible with a microscope, but the former process shows a more skilful and less mechanical approach to the work in hand. Considerations along these lines will eventually provide fuller ideas of chronological and regional distinctions, and help identify individual workshops.

The starting point for jewellery was gold or silver, perhaps often as scrap or, after the mid-first century BC, coins. Odd coins, cut coins, ingots and fused bits of scrap have all been found in jewellers' hoards. The recently found hoard of Roman silver jewellery from Snettisham, Norfolk, in England, contained numerous silver and bronze coins plus silver scrap.

Sheet metal

Gold or silver was first melted into a convenient small mass, ingot or rod that was then cut, hammered and otherwise worked. Often gold was hammered into a thin sheet which was shaped in various ways into the basic form of an object or component. This could then be embellished with granulation, filigree and other decoration. A complete object might well be composed of many separately made components joined by soldering or by rivets or wire links.

This basic assembly from hammered gold was used for the majority of ancient goldwork, from elaborate Egyptian necklets to starkly elegant Greek gold rings. The thickness of the hammered sheet depended upon its intended function and local economics. Etruscan goldwork, for example, is far flimsier than most Hellenistic. Much ancient goldwork is composed of sheet gold about 0.1 mm thick. Non-structural parts could be even thinner, while larger objects suitable for heavy-duty use – such as some bracelets and rings – could be formed from solid rods. Of course, gold was expensive and a compromise had to be made between sturdiness and cost. A simple bangle made from a solid rod of gold can contain more than ten times the amount of gold needed for a similarly sized bangle made from a sheet-gold tube. Some Roman finger rings were made from remarkably thin sheet gold very precisely burnished into complex forms. Such rings would be easily crushed if they were not filled with sulphur (see p. 44). The Roman author Pliny suggests that such rings were deliberately made of thin gold so that they would not jar and crack any set stone if they were dropped; it is probable that economics also played a part.

Gold when quite pure is soft and malleable and sheet gold can be pushed into quite complex forms with the simplest of tools. People involved in replication experiments to recreate ancient goldsmiths' methods will often have little success if, for economy's sake, they use low-carat gold alloys or even silver. Goldsmiths generally used basic hand-held tools of wood or bone, as well as metal, and a large proportion of ancient gold jewellery was produced freehand without any more elaborate equipment. However, when several identical forms were needed, a variety of semi-mass production methods could be used.

Simple repetitive forms in sheet gold were produced in the early third millennium BC and imply the use of 'formers' or dies over or into which the sheet could be pressed. Once into the Iron Age repetitive forms became more common. The two Rhodian plaques in figure **25** had their design impressed with the same die. The tools could be made of copper alloys, wood, bone or stone and take the form of a raised positive, like a cameo or coin, or be cut in intaglio – a tool of this latter

type is shown in figure **26**. Here, the sheet gold would be pressed down into the design by means of wooden tools or, perhaps, by placing wax or lead over the gold and hitting this with a hammer. Much of the gold and silver jewellery produced in India to this day is made with brass dies in just this manner. A copper-alloy former with a design in relief is illustrated in figure **27**. This was for producing the back and front of lynx-head terminals for Hellenistic earrings of the type shown in figure **28**.

Ancient copper-alloy punches range from simple, round-headed 'doming punches' to those for producing masks or figural forms (fig. **29**). The gold sheet was placed on a resilient backing such as resin or lead and the punch was then driven into the gold by means of a hammer.

When objects were made from very thin sheet gold they were frequently filled with some substance that would add strength and weight. In some cases clay, plaster or a similar material was used which could be put in place prior to any soldering, perhaps helping in the shaping of the object. An alternative class of filler was made from materials with low melting temperatures which had to be added after all the heating processes, such as soldering or enamelling, had been completed. Hellenistic goldwork can contain resin or wax mixed with marble-dust, and Roman-period jewellery is often filled with sulphur. Sulphur is an ideal filling material because it melts easily, can be poured into a small space, and sets solid without contraction. Sulphur crystallises with time and ancient Roman gold now often contains sulphur of a friable, almost powdery consistency.

25 (*top*) Seven necklet elements from Rhodes decorated with impressed representations of female deities, filligree and granulation. 7th century BC. British Museum, BMCJ 1128.

26 (*above*) One face of a bronze goldsmith's die for impressing thin sheet gold. All four sides bear designs. From Corfu, Greece. *c.* 700 BC. Ashmolean Museum, Oxford, G 437.

27 (*above*) Bronze former. Thin sheet gold would have been pressed over the design to make the back and front halves of a lynx head as in figure **28**. 1st century BC. Private collection.

28 (*right*) Gold and garnet earring with lynx-head motif. The earring was worn with the head facing up to the front of the ear-lobe, the chain probably passed over the ear, *c.* 1st century BC. British Museum, BMCJ 2442.

29 (*below*) Two ancient bronze punches used by goldsmiths. The Roman one (*left*) was for forming domes, the earlier Western Asiatic one (*right*) produced an animal design. Private collection.

Wire

Wire found a myriad of uses in ancient jewellery, from long chains to delicate applied filigree. Modern wire is generally produced by a process called wire drawing: a cast or hammered rod of metal is made longer and thinner by pulling it through a hole in a 'draw-plate'. The process is repeated through consecutively smaller perforations until the wire is of the desired gauge. Wire drawing leaves parallel striations along the length of the wire.

Microscopic examination of thousands of ancient gold objects reveals that wire drawing was not introduced until after the Roman period. Possibly some metal wires were being drawn by about the seventh century AD, but drawn gold wires probably only came into general use from about the ninth century and did not become universal for several hundred years.

The simplest type of wire is a thin strip of gold cut from the edge of a sheet. This can be converted to a circular-section wire by various means. The simplest is by gentle hammering. Very regular wires can be made by this method, but it is not really suitable for wires under one or two millimetres in diameter. The thinner-gauge wires in antiquity were normally made by twisting a strip cut from sheet gold. This is an easy process; the strip – probably seldom much more than about ten centimetres long – is held between the fingers of the two hands and

30 Diagram of gold wire production methods. The starting point was usually a strip cut from a sheet (*a*). Twisting this strip would produce a tighter and tighter length (*b, c*) which was then rolled between two flat surfaces, such as wood, to produce a round-section wire (*d*). If the initial strip was narrow relative to its thickness, twisting naturally resulted in a tube-like coil (*e, f*). This can also be rolled to produce a round wire (*g*). In both cases (*d* and *g*) traces of spiral 'seam lines' are usually visible. Round wires could be rolled under a double-edged implement to produce a beaded wire (*h*) or under a single edge held at an oblique angle to produce spiral-beaded wire (*i*). Taking a tube-like coil (as in *f*), flattening this (*j*), and then unfolding it results in a decorative 'wavy ribbon' (*k*).

gently twisted. Two things can happen: either the strip just twists tighter and tighter or, if the original strip is thin relative to its width, it will eventually coil into a tube-like length. Either type of twist is then compacted by rolling it between two flat surfaces – wood works well (fig. 30). Wires produced by this method show characteristic spiral 'seam' lines along their length (fig. 11). There have been various attempts to characterise (and name) different types of twisted wire, but since the types of twist really depend on the ratio of width to thickness of the initial strip and the malleability of the alloy, it is perhaps more appropriate simply to call all such wires with spiral seams 'strip-twisted' wires. Most ancient wires show the seams spiralling in the same direction – what a textile specialist would term an S-twist, rather than a Z-twist. This is only to be expected, as the majority of ancient goldsmiths were presumably right-handed. Until a decade or so ago, forgers were largely ignorant of ancient wire production methods and older forgeries are often readily detectable because they include wire made by the post-Roman drawing technique.

A rarer ancient type of wire appears to have been formed by pulling a thin gold strip through a round hole in a piece of metal, wood or bone – the strip curls round to produce a round wire with a single seam line running along its length. This type of wire tends to be weak, since it is typically a tube, and buckles and opens along the seam when it is bent into curves. Strip-twisted wires are more serviceable.

Decorative wires

The ancient goldsmith also produced a variety of decorative wires. One of these, popular from about the seventh century BC onwards, is termed 'beaded wire' because it resembles a line of small beads (fig. 31). This type can be easily produced by rolling a circular-section wire under a single or multiple edge, as shown in figure 30h. Beaded wire remained popular right through into medieval times.

It is difficult to produce very fine-gauge beaded wire, so finer decorative wires were made by rolling them under an oblique single edge, producing a groove like a screw-thread along the wire (fig. 30i). This type of spiral-beaded wire is typical of much Etruscan and Hellenistic filigree.

Another decorative effect is 'wavy ribbon', a decoratively ridged strip that first occurred at the beginning of the Christian era, although it was not widespread until the third century AD. This attractive type of strip (as seen around the peridot pendant in fig. 21) is remarkably easy to produce. A narrow ribbon of gold or silver is wound into a spiralled tube-like coil. This is then flattened and unwound to reveal a strip creased with a regular series of wave-like ridges (fig. 30j–k). This type of wire died out after the seventh century AD.

Chain

Chain required a great deal of wire: a gold chain necklet can consist of many metres. Most modern chains are of the simple link type – that is, each circular or oval link passes through the previous link of the chain (fig. 32a). In this type of chain, each link has to be soldered up after assembly. With ancient soldering methods (see p. 51) the links could easily fuse and reduce the flexibility of the chain; to avoid such potential problems the majority of ancient precious-metal chains were produced by the so-called 'loop-in-loop' method. Each oval wire link

47

31 (*left*) Scanning electron microscope view of a section of beaded wire filigree on an Etruscan gold ornament.

32 (*below*) Diagram showing some ancient gold chain types: (*a*) simple or plain chain; (*b*) basic loop-in-loop chain; (*c*) figure-8 loop-in-loop chain; (*d*) doubled loop-in-loop chain; (*e*) three fold doubled loop-in-loop chain.

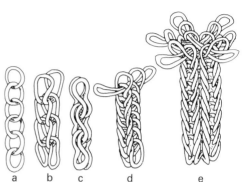

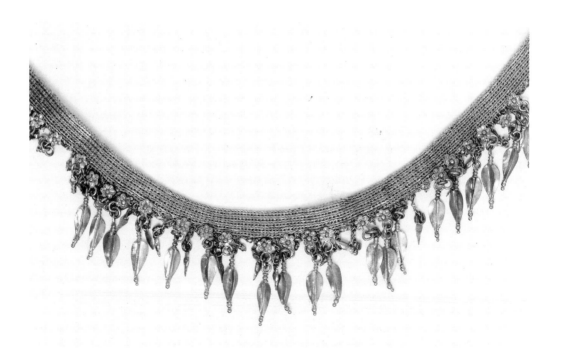

33 Centre section of a Hellenistic gold necklet of 'strap' type, with rosette and spear-head pendants. The strap, which consists of five loop-in-loop chains held side by side by transverse links, ends in heads (not visible here). *c.* 300 BC. British Museum, BMCJ 1943.

48

was soldered up and the complete link was then threaded through the previous one, as shown in figure **32**. Elaborations included multiple links where each link passed through the previous two links, or chains where links crossed each other at right angles, or where three sets of links intersected at 60-degree angles.

So-called 'straps' were made by linking separate chains side by side. These are first found around the eighth or seventh century BC and the recently excavated Nimrud treasures include what might be the oldest known example. Strap necklets, often with a fringe of small pendants and worn pinned from shoulder to shoulder, are typical of the Hellenistic period (fig. **33**). Straps, though rather coarse examples of them, are occasionally found in early Roman jewellery. Chain necklets, including straps, have been a favourite among forgers for well over a century.

Pierced work

Simple and often very repetitive pierced work was made from the Bronze Age onwards but reached its pinnacle in the late Roman and early Byzantine periods. The most delicate pierced work, sometimes called *opus interrasile*, resembles fine lace (fig. **34**) and was produced by making a series of small holes in the gold sheet and then opening up these holes by means of a small, sharp tool. The goldsmith needed considerable skill to visualise the desired patterns in terms of a series of holes and to then cut out the notches in them. For complex work, the goldsmith first sketched out the pattern on the sheet gold with a sharp point.

Casting

Metal castings were produced from the earliest days of the Bronze Age, but cast-gold jewellery was never common. Casting requires a mould (of stone, metal, clay or plaster) into which the molten metal must be poured. All but the

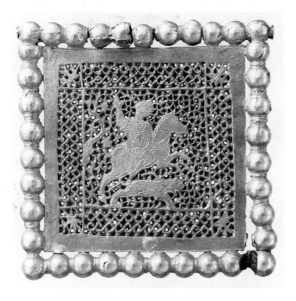

34 Gold plaque with a fine pierced-work depiction of a huntress. The plaque is bordered with thick beaded wire which, along the top edge, conceals a hinge. The pierced work was carried out by punching a large number of small holes through the sheet gold. These holes were then opened out with notches cut with a triangular-ended gouge or engraver's tool to produce the intricate lace-like effect. 4th century AD. British Museum, MLA AF 332.

most primitive moulds have an inlet funnel into which the molten metal is poured and which also acts as a reservoir to provide a good weight of molten metal to help fill the mould. Even if it was possible to melt the precise amount of metal to fill a given mould, or to manufacture a mould that would utilise a given weight of metal, the finished object would still have an attached 'sprue' of the metal that solidified in the inlet funnel. Clearly more metal has to be melted than is required for the final object – an undesirable factor in ancient times when patrons supplied the gold or it was specially purchased on their behalf.

There are some examples of ancient cast-gold jewellery, such as some Egyptian signet rings and pendant statuettes, but in general even the most massive Roman gold rings and fibulas were made by a combination of hammering and soldering. Goldsmiths in prehistoric Europe, however, became masters of casting gold and even used casting-on, a process whereby a terminal, for example, can be cast *in situ* around the end of a previously formed neck-ring. Cast silver jewellery was also rarer than is usually supposed, but casting was commonly employed for copper-alloy ornaments of all types.

The commonest ancient casting process was the so-called 'lost wax' technique. Here, a wax model of the required object is coated in successive layers of clay or plaster which are allowed to harden (fig. **35**). A conical hole is drilled through to the wax model; the mould is then heated, the melted wax poured out and molten metal poured in. The mould has to be broken to remove the casting, so each cast is unique – although the wax models can themselves be mass-produced in terracotta or stone moulds. Very occasionally we can see clear evidence that a gold object has been cast by the lost wax technique. For example, some cast gold objects have one or two microscopic spherical protuberances that can look almost like granulation, but in fact these are small gold spheres caused

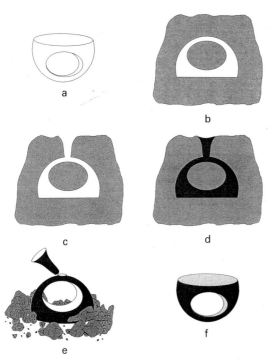

35 Diagram showing the process of lost wax casting. A wax model or 'antetype' is made of the desired object – here a ring (*a*). This is coated in several layers of plaster or clay (*b*) which then dries or is fired. A conical hole is drilled through this 'investment' and the wax burned or melted out (*c*). Molten metal is next poured into the mould (*d*) and then, once the metal has cooled and solidified, the mould is broken off and the 'sprue' cut away (*e*). The casting is then finished and polished as required (*f*). For complex castings more elaborate moulds may be necessary, for example, with exit canals to allow the escape of hot air and gases.

by gold entering air bubbles on the inner surface of the original plaster or clay mould.

Soldering and granulation

Most ancient goldwork involved some soldering process – to join the hoop of a ring, add a suspension loop to a pendant, or apply filigree and granulation.

In the various processes which can be loosely grouped under the term 'soldering', molten metal is introduced into the joint area and then cools and solidifies, firmly bonding the components together. One way of doing this is by so-called 'fusion welding'. Here the parts are heated in contact; at a temperature dependent on their precise composition the surfaces begin to melt and flow together. When cool again, the parts will be firmly joined. This process requires great care and observation in the heating. It can be used to join small grains but is not really suitable for joining thin sheet gold, since this melts too readily.

A safer joining method involves an alloy of lower melting temperature than the metal being joined. If two gold components are placed together and a small amount of a gold alloy with extra silver and/or copper is placed in the join area, this joining alloy or solder will melt when heat is applied and join the parts. Some writers use the term 'brazing', but this should technically be reserved for copper-alloy solders as used to solder iron and copper alloys. Solders can be naturally occurring or artificially made alloys. In earliest times a naturally occurring electrum (a gold-silver alloy) was used to solder gold. The addition of copper to a gold alloy produces a more drastic reduction in melting temperature and also gives a solder joint that is less pale in colour. The solder alloy is applied to the joint area in the form of small clippings or powder and the work heated. The heat itself can be produced in a small furnace or by means of an oil-lamp flame plus a blowpipe to direct the heat.

When very small components such as filigree wires or granulation are being soldered in place it is difficult to employ a sufficiently small quantity of solder so as not to flood the joint area. One method of overcoming this problem is a process that has been termed 'colloidal hard soldering' or 'diffusion bonding'. Various versions can be used, but a simple one is as follows. A copper compound (such as copper acetate formed by the action of vinegar fumes on copper) is mixed with a little water or glue to form a liquid. This mixture is placed in the joint areas or, in the case of granulation and filigree, it can be used to hold the individual components in position. The work is heated and the copper in the mixture reduces to metallic copper which, in turn, alloys with the surrounding gold and forms a solder in the joint. Such soldered joints are neat and very unobtrusive.

The term granulation is used today to refer to the minute spheres of gold, and less commonly silver, used to provide geometric or figural decoration. The name derives from the similarity of the tiny gold spheres to small seeds or grain. The ancients saw the same similarity: the Greek name for granulation was *kegchros*, meaning millet.

Perhaps the earliest examples of granulation are two pieces from the grave of Queen Pu-Abi of the Early Dynastic period (*c.*2500 BC) at Ur, in modern Iraq. One of these is a small bead composed of six gold granules arranged in a circle. The other is a sheet-gold strip with applied gold grains. Analysis of both objects indicates that the grains were joined by heat alone without any solder alloy – that is, by the fusion welding process described above.

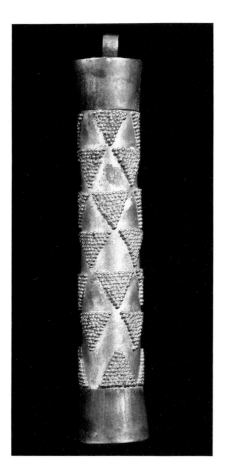

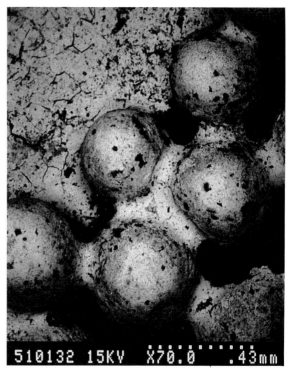

36 (*left*) Gold cylinder pendant from Harageh, Egypt. *c.*1900 BC. Petrie Museum, University College London, UC 6482.

37 (*above*) Scanning electron microscope detail of figure **36**. Each of the 1848 grains is about 0.4 mm in diameter.

One of the earliest examples of soldered granulation to have been studied is a gold cylindrical amulet case dating from the Egyptian Middle Kingdom, *c.*1900 BC (figs. **36** and **37**). Here, the grains are arranged in a precise triangular pattern and neatly soldered with a silver-rich gold alloy. Granulation is actually strangely rare in Egypt at all periods and was seldom used for the inlaid, almost icon-like traditional jewellery. Granulation reached its peak in the ancient world just before the middle of the first millennium BC, not only in the well-known Etruscan granulated jewellery but also in the work of Phoenician (fig. **38**) and Western Asiatic craftsmen.

Early Hellenistic goldwork makes sparse use of granulation but, as the Hellenistic period progressed, the technique came into favour again – along with a generally flimsier, more colourful approach to goldwork in general. This Hellenistic baroque style survived into Roman times in the East, but in Italy itself, and in Roman Egypt, the taste was for simple, starker designs made from far fewer individual components and, as a result, minimal granulation. Late Roman jewellery swung back to more ostentation and colour, but granulation never again reached its earlier popularity.

The grains used in granulation work range down to well under a millimetre in diameter. A simple way of making these grains is by heating small bits of gold on charcoal. When they melt they roll up into spheres as a result of surface tension.

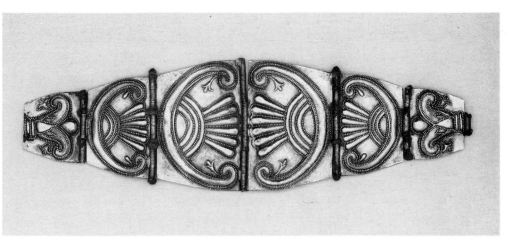

38 Phoenician hinged gold bracelet from Sardinia, decorated with precise granulation. The sections are hinged on silver pins for strength. *c.* 7th–6th century BC. British Museum, WAA 133392 (part).

The skill in granulation lies in the accurate placement of the grains, not in their manufacture.

Silver jewellery was assembled in much the same way as gold, with silver-copper alloy solders. Copper-alloy ornaments were usually cast in one piece or assembled by means of rivets and other mechanical means; soldering was unusual. When copper-alloy objects were soldered, this was usually carried out with some type of copper-based brazing alloy. In a few cases so-called 'soft solders' made from lead and/or tin were used; occasionally a silver solder was employed.

Various mechanical joining methods were also used to assemble complex gold ornaments. These typically include small rings of gold wire, rivets and gold versions of the split pins used by modern engineers. Mechanical joining methods were used to simplify assembly, retain flexibility and avoid damage caused by the repetitive use of heat for soldering.

Other processes

Numerous other processes were also used for working precious metals in antiquity, although some implements that we take for granted today were not used. For example, the fine jeweller's saw, files and shears were seemingly not employed, and if microscopic examination reveals the characteristic marks left by these tools, the authenticity of the object needs to be carefully considered. From medieval times onwards gold and silver were frequently engraved, that is, inscriptions or decorative patterns were gouged out with a sharp implement. In antiquity designs were more commonly produced by chasing, that is, by using a small chisel-like tool which depressed or displaced the metal rather than carving it out. In part this can be explained by the widespread use of thin sheet metal in antiquity which would be hard to engrave without cutting right through it. However, recent microscopic examination has shown that a few solid gold and silver rings of Greek, Phoenician and Roman origin are engraved, although with fairly shallow grooves.

39 Simple bow-drill (*left*) of a type used throughout history; (*right*) the principle is similar, but here the drill is mounted horizontally to provide a more versatile and precise implement. The rotating tip can now be used as a drill, or it can hold variously shaped polishing or gem-cutting wheels.

Stone working

The majority of the gemstones used in antiquity prior to the middle of the Hellenistic period were no harder than quartz and so could be cut, abraded and polished by means of sand and even flint. Beads, inlays and other components could be shaped by rough chipping followed by grinding and polishing. Drilling was carried out by means of a simple bow-drill (fig. **39**), with either a flint point or a wood or metal point fed with an abrasive. Some stone cutting lent itself to semi-mass production methods. One Egyptian wall painting shows a bead maker with a multiple-drill bow-drill, probably drilling a series of beads (a feasible process, as modern experiments have shown).

Harder abrasives such as emery (aluminium oxide) only became necessary in the Hellenistic and later periods when harder gemstones such as emeralds and sapphires came into use. By Hellenistic times diamond-tipped drills were employed by stone-bead drillers, and probably also by gem engravers (fig. **22**). Diamonds were too hard to cut or polish and, when used in Roman rings, were always left in their natural crystal form.

By the beginning of the Iron Age, a gem-cutting and polishing tool with a lathe-like horizontal axis of rotation had come into use (fig. **39**). This meant that wheel cutting and rotating disk polishing could supersede drilling and rubbing.

The traditional way of shaping and polishing gemstones is to place the stone on to the end of a stick or 'dop' and hold it against a rotating abrasive wheel using the stick as a handle. In modern India some skilled gem polishers can hold a dozen or more dops in their right hand while polishing them all on an abrasive wheel driven by a bow mechanism with their left hand.

Simple mass production methods are, by their very nature, easy to postulate but often impossible to prove. For example, a typical early Sumerian bead form is lapis lazuli cut to a biconical shape, as seen in figure **40**. It might be supposed that these beads were made by perforating a roughly shaped piece of lapis, placing this on the end of a rod and then rotating it in a conical depression fed with an abrasive. However, observation of unfinished beads shows that they were drilled after final shaping, and that both ends of the bead consist of cones with sides of the same angle – an unlikely result with most types of hand abrasion. One production method that replicates these features is to place rough pieces of lapis between two flat abrasive stones and then move the upper stone with a slight horizontal circular motion. This causes the pieces of lapis to roll about their central axes and grinds them into perfect bicones – lapis is of an ideal structure and hardness for this type of production.

Grinding between two flat stones might also have been used to form the thin parallel-sided garnets that are so typical of Dark Age European jewellery – for example, those in figure **3**. Here, the garnets were probably stuck to the lower block to prevent them from rolling around.

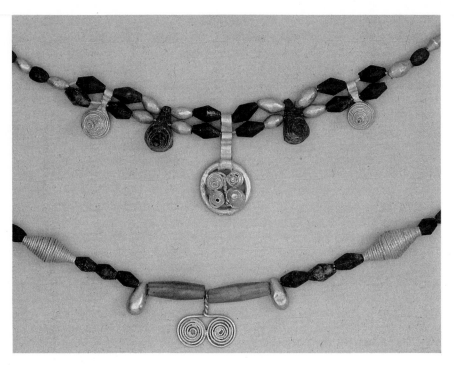

40 Two necklets consisting of biconical lapis lazuli, gold and carnelian beads plus gold spiral pendants. Found in the Royal Cemetery at Ur, Iraq. The gold work is fairly rudimentary and the soldering crudely carried out – the quadruple-spiral pendant on the top necklet was overheated and has partly melted. British Museum, WAA 121425, 6.

Timing the craftsmen

It is interesting to try to gauge the amount of time that a jeweller might have taken to make his wares. On the basis of modern practice and replication experiments it is likely that the average gold ornaments for middle-class members of society represented a few hours' to a few days' labour. Only more elaborate jewels would take a week or more. The time taken would reflect the size and complexity of the work and the skill and number of the goldsmiths concerned. In many cases a goldsmith might work alone with just a son or an apprentice or two to help. The larger workshops in urban centres could employ several goldsmiths and slaves as well as apprentices. Royal palaces and temples often had their own workshops with relatively large work forces. We do not know how labour was divided in such workshops, but common sense and observation of recent practice in many parts of the world suggest that the skilled work was carried out by the better goldsmiths, while those less skilled did more repetitive tasks such as making wires, granules and linking chains. In certain cases, such as some pairs of Dark Age brooches, one is of finer-quality workmanship than the other, suggesting that the master made one and then left an apprentice to make the other.

— 5 —

Goldsmith and Patron

In search of the goldsmiths

The materials and techniques used to make ancient jewellery are only part of the story. We should also try to understand the relationship between goldsmith and patron and the significance of the choices they made regarding technique and material. One of the satisfactions of studying ancient jewellery lies in obtaining insights into the mind and ingenuity of individual goldsmiths.

In the finest work we can see refinements and precise details that were almost certainly too subtle or too minuscule to have been noted by the original clients. Thus modern microscopes give us an intimate and unique link with the original goldsmith across two millennia or more. At the other end of the scale, we can observe how lesser craftsmen disguised or compensated for small errors or shortfalls in materials. We can often spot ancient repairs, carried out when a link wore thin or a peg holding a stone snapped off. Some jewels were adapted in antiquity, often by a less skilled craftsman than the original maker.

Tradition and a conservative clientele probably left little scope for creativity in terms of the overall form and function of jewellery. Generally only the quality of workmanship or the choice of decoration points to different hands or workshops. The anonymity of ancient goldsmiths is remarkable. We find some engraved gems and silverware with makers' names, but no gold jewellery. Despite all the surviving jewellery and written evidence about jewellery that has survived, particularly from Roman Egypt, it is exceptionally rare to be able to identify surviving goldwork with the name of its maker.

One such instance is a recent find from a Babylonian temple in Iraq which dates from around 1740 BC. Here, a sealed jar was found to contain a seal naming the goldsmith Ilsu-Ibnisu, fine samples of his work, tools including weights, scrap silver for remelting, and a collection of agate, carnelian and lapis lazuli beads. The hoard was found in a room that can be identified as the workshop. Examples of jewellery from this find show that Ilsu-Ibnisu was a competent goldsmith, well acquainted with filigree and granulation work. Granulation was at that time becoming popular all over Western Asia. The cosmopolitan nature of jewellery of this period is also reflected in the presence of quadruple spiral beads

in the find; these resemble spiral beads found over a very wide area, from Troy in eastern Turkey right across to Iran and even Pakistan.

In some cases careful comparisons of styles and techniques have permitted the tentative grouping of ornaments as being the output of a single craftsman or workshop. The Rhodian ornaments in figure 25 are an obvious example: they were all made with the same former. Very recently a programme of analyses of the solders used to assemble goldwork in Iron Age Spain have allowed a tentative characterisation of the solders used by some individual workshops. It has been suggested that the two ornaments from southern Italy (figs. 41, 42) are part of the output of a single goldsmith, dubbed 'the Santa Eufemia Master' after the treasure which supplied the first examples of his work. One characteristic of his work is the flattened tapered tendrils made of corkscrew-like coils of wire.

Some copper-alloy jewellery does bear the name of its maker and in some cases distribution maps of particular copper-alloy brooch forms have allowed us to determine the likely site of the original workshop. Theoretically, whenever we have a sufficiently large and homogeneous group of jewellery, it should be possible to recognise some evidence for a limited number of hands. There is enormous scope for further study along these lines, whether with bronze rings from Europe or the goldwork found in Tutankhamun's tomb.

Goldsmiths like Ilsu-Ibnisu who worked in temples were a normal phenomenon in the ancient Near East. The Egyptian goldsmiths we hear about were all attached to the temples. Although there is minimal evidence of temple goldsmiths carrying out work for outside customers, we must assume that this happened. In Roman times, temples sometimes provided a site for goldsmiths' stalls.

The establishment of independent goldsmiths' workshops, with stalls or little shops, within the market places of ancient cities can really only be attested from the Hellenistic period onwards. The craft was often passed down from father to son, although slaves were sometimes employed and, in some known instances, freed slaves started their own jewellery businesses. The most successful goldsmiths are likely to have become quite rich and well known, but the average goldsmith probably never amassed much capital and largely worked or

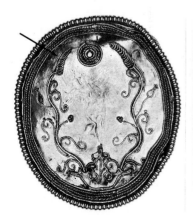 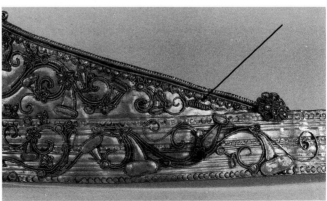

41 and **42** Gold pendant (*left*) and detail of a gold diadem, both from Santa Eufemia in southern Italy. The general use of wire filigree is typically Hellenistic, but these pieces and certain other gold jewels show stylistic and technical similarities (such as the corkscrew coils shown by the arrows) that suggest they were the output of a single goldsmith – dubbed the Santa Eufemia master. Late 4th century BC. British Museum, GR 1896.6–16.4, 1.

reworked the raw materials provided by his customers. Itinerant craftsmen probably saw to the needs of the villages and countryside, but the ancient equivalent of the landed gentry no doubt travelled to the nearest urban centre for any serious goldsmithing commission.

Some goldsmiths travelled to other lands as demand required. A text relating to the building of Darius' palace at Susa in Iran notes that the goldsmiths employed were Egyptians and Medes (the gold itself came from Asia Minor and Afghanistan). An inscription from Alexandria tells us that a goldsmith from Egypt migrated to Italy in the first century AD. If he was but one of many, this might explain the close similarities between the jewellery of this period found in Egypt and Italy.

Roman and Byzantine Egypt have provided us with a great deal of written information about jewellers and their work. Surviving papyri include dowry lists, lists of stolen jewellery, contracts between goldsmiths and patrons, references to goldsmiths' and silversmiths' guilds, and even an indignant letter from a goldsmith to his client defending his work against accusations of sloppiness. Egypt has also provided the nearest we have to a jeweller's workshop manual. This papyrus, now in Leiden, contains methods of testing, cleaning and refining precious metals, recipes for making solder alloys, methods of plating and various means of imitating precious metals. A companion papyrus in Stockholm has many recipes for manufacturing imitation gemstones – mainly by dyeing quartzes and other minerals.

Based on what we know of late Roman and early post-Roman practice, it is probable that the goldsmith would make up jewellery for a particular customer working with gold supplied by that customer, or purchased with the customer's money. Some of this gold was in the form of coins and some in the form of scrap, typically damaged or outdated objects. Many ancient jewellers' hoards contain scrap, including broken-up and partly melted gold and silver ornaments. Others often contain coins – sometimes partly cut up for reuse. The common practice of recycling precious metal is vividly illustrated by a surviving document from sixth-century AD Egypt which describes how silver stolen at night from a monastery was sold to a silversmith who melted it down and made it into spoons.

There is little evidence for the rates of pay for goldsmiths prior to the late Roman period. Temple goldsmiths were presumably full-time employees, but goldsmiths and tinkers working for the general population must have charged a fee for their work. In most cases the fee was probably based on the weight of the object and, sometimes, the complexity of the work. Gold and silver were more valuable in antiquity than today – in relative terms – and the goldsmith's fees were probably minimal compared to the cost of the raw materials. In only one case, a fragmentary text from Roman Egypt, do we have a hint that goldsmiths might sometimes have been paid for the time they took to make the object.

An edict of the emperor Diocletian of AD 301 laid down the amounts that could be charged for goldsmiths' work. Simple work demanded 50 denarii per ounce, more intricate work 80 denarii per ounce. From a knowledge of the contemporary gold price we can calculate that these represented profit margins of only 0.83 and 1.33 per cent respectively! A papyrus from Egypt tells us that a few years later a goldsmith earned 100 denarii per ounce but, since gold prices had increased enormously, this represented the even lower profit margin of 0.27 per cent.

Silversmiths were in a different position. Silver was less valuable than gold, so a jeweller working in silver would be more likely to build up some stock. Such

a stock can be seen in the second-century AD hoard recently found at Snettisham, with its scrap silver, coins, unset stones and numerous completed silver rings. There is little evidence as to how much the jeweller would have been paid for his work, but in the early fourth century, according to Diocletian's edict on maximum prices, a silversmith should charge 75, 150 or 300 denarii per Roman pound of silver, depending on the complexity of the work. Simple jewellery would probably only qualify for the lowest rate.

Gemstones were probably also sold by weight but, according to the scant information we have, there appears to have been more leeway with regard to price. Pearls, for example, were expensive, and large, good-quality pearls could command very high prices. The price for run-of-the mill pearls was probably more or less fixed, but for anything a bit out of the ordinary, say a matched pair of pearls, the dealer could probably negotiate his own price. The Roman writer Aelian noted that pearl dealers could become rich.

Numerous Roman inscriptions and texts refer to guilds of goldsmiths and silversmiths, and by then such guilds probably existed in most main urban centres. Texts show that a guild would look after the interests of its members and also guide the public and act as arbitrator in case of disputes. Guilds facilitated the circulation of precious metals and the taxation of guild members.

The patrons

Gold jewellery implied wealth. Clement of Alexandria, in the late second century AD, tells a story about the great Greek artist Apelles examining the work of an untalented pupil. Noting the abundant gold jewellery that the pupil had depicted on his painting of Helen of Troy, Apelles said: 'Boy, being incapable of painting her beautiful, you have made her rich'.

We know the names of the owners of particular objects of jewellery far more often than we know the names of the makers. This is particularly true of early Egyptian jewellery. Royal pectorals usually bear the name of the king, often with his titles and sometimes including very unsubtle propaganda. At all periods signet rings could bear the name of their owner (fig. 43). During Hellenistic and

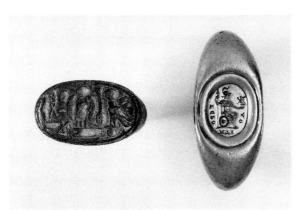
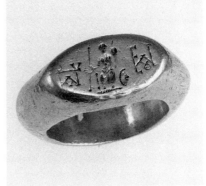

43 Silver ring (*left*) from Cyprus, bearing titles of the Egyptian Pharaoh Akhenaten, *c.* 1430 BC; Roman gold ring (*centre*) with a depiction of the goddess Roma and the name Gerontios, from the Tarsus Treasure, *c.* AD 300; early Byzantine gold ring (*right*) showing a seated goddess flanked by monograms. British Museum, BMCR 997, BMCR 188, MLA 1964.12–4.1.

Roman times the popularity of engraved gems and signets tended to displace names of owners from most ring bezels (a possible exception is shown in fig. **43**), but in the Byzantine period names again became more frequent (fig. **43**). On some such rings the names are written in a cryptic monogram which cannot always be interpreted. Some Byzantine rings bear inscriptions specifically asking God or the Virgin Mary to help the wearer, who is either anonymous or specified. The latter rings were presumably made, or at least engraved, to order, while rings without names might have been purchased from stock.

In the earliest times, temple or state goldsmiths worked hard to provide their royalty or the images of the gods with jewellery befitting their importance. Nobles sought gold jewellery that would indicate their rank and, as far as possible, emulate the ornaments worn by their rulers, who could also distribute gold jewellery to their subjects as a reward for valour or support.

From early Egypt and Western Asia we have no certain evidence for any type of sumptuary laws limiting the ownership of gold to those above a certain social level, although we might suspect that something along those lines existed. Limiting gold ownership would confirm the status of the upper ranks and limit the gold in private hands. In early Roman times there were strict laws regarding who was allowed to wear a gold ring, and even high-ranking families were limited as to the total weight of gold they were allowed to possess. With time the laws relaxed, but there were still some limitations. The emperor Septimius Severus allowed soldiers to wear gold rings in a proclamation of AD 197, and in AD 539 the Byzantine emperor Justinian gave freed slaves the same right. A law of AD 593 ruled that 'no actresses of mimes shall wear gems . . . of course we do not forbid them to wear . . . gold without gems on their necks, arms and girdles'.

We can assume that the middle classes aspired to own gold. Dowry lists that have survived from Roman Egypt show that a few gold ornaments were quite commonly included among the dowries of women who were far from rich. There is one particular family from the village of Tebtunis in Egypt in the second century AD for which we have a great number of surviving documents. These show that a man who was essentially a tenant farmer, with a financial situation veering from dire poverty to moderate comfort, gave one of his daughters a dowry of gold jewellery plus silver money worth around 520 drachmae. This probably equalled his earnings for about a year.

The desire for jewellery in the ancient world relied on much the same emotions as today. Jewellery was given as gifts at births, birthdays and weddings. Egyptian pharaohs distributed gold collars, pendants and rings to favoured subjects, and lesser Egyptians gave simple faience rings as New Year gifts. There is not much evidence that the age of jewellery was considered a virtue in itself, although there are various references to jewellery remaining in a family for more than one generation. Jewellery might well have been worn because of its religious or amuletic significance, but sentimental attachment must not be forgotten. From an early Egyptian literary text we hear of a girl rower, part of a sort of exotic aquatic cabaret, dropping her fish pendant into the water. Even though the pharaoh himself offered to give her another identical one, she still demanded the return of her own. This apparent extreme sentimental attachment to a jewel – the earliest reference to such – was rewarded by the fortuitous intervention of a magician who made retrieval possible.

Greed and one-upmanship was another powerful emotion. Several Roman writers complain how women's greed for jewellery could ruin their husbands.

With the coming of Christianity, the early Church fathers frowned on the wearing of jewellery. However, the wealth of superb early Byzantine gold jewellery shows that religion could not displace the desire for gold. Excuses had to be made. Clement of Alexandria, in the late second century AD, comments: 'Allowance must sometimes be made in favour of those women who have not been fortunate in falling in with chaste husbands, and who adorn themselves [with jewellery] in order to please their husbands'.

Postscript

This brief study has tried to show that jewellery, often simply viewed as treasure, frippery or the trappings of a past élite, is just as worthy of archaeological study as pottery lamps or fish bones. Jewellery is remarkable for the enormous variety of methods by which it can be considered and the diverse ways in which it can increase our understanding of past societies. At one extreme we have the major and trace element analysis of the materials – which can provide a wealth of information about sources, trade and economy – and at the other end of the scale is the art historical approach, which can deduce chronological and geographical patterns and place jewellery in its artistic context. Between these two extremes is the study of the technology and, perhaps equally important, of the assembly details – that is, how and why the techniques were employed in particular instances. When we add to all these the opportunities to examine the myriad representations of jewellery in wear, and to read and interpret the thousands of ancient documentary references to all aspects of jewellery production and use, we can see that there is enormous potential for research in the field. If this book has inspired any of its readers to look at ancient jewellery more closely, or prompted archaeologists to re-evaluate the information available from or about jewels they have excavated, it will have served its purpose.

Further Reading

Recommended general reading (English language only)
Aldred, C. *Jewels of the Pharaohs*. London, 1971.
Andrews, C. *Ancient Egyptian Jewellery*. London, 1991.
Boardman, J. *Greek Gems and Finger Rings: Early Bronze Age to Late Classical*. London, 1970.
Higgins, R. *Greek and Roman Jewellery*. 2nd edn, London, 1980.
Johns, C. and Potter, T. *The Thetford Treasure, Roman Jewellery and Silver*. London, 1983.
Maxwell-Hyslop, K.R. *Western Asiatic Jewellery, c. 3000–612 BC*. London, 1971.
Ogden, J.M. *Jewellery of the Ancient World*. London, 1982.
Ogden, J.M. *Gold Jewellery in Ptolemaic, Roman and Byzantine Egypt* (in preparation).
Tait, H. (ed). *Seven Thousand Years of Jewellery*. 2nd edn, London, 1986.
Wilkinson, A. *Ancient Egyptian Jewellery*. London, 1971.

Most of the above books provide detailed bibliographies.

Catalogues of collections
Hackens, T. *Catalogue of the Classical Collection, Classical Jewellery*. (Museum of Art, Rhode Island School of Design.) Providence, Rhode Island, 1976.
Hoffmann, H. and Davidson, P. *Greek Gold: Jewelry from the Age of Alexander*. New York, 1965.
Kent, J. and Painter, K. *Wealth of the Roman World AD 300–700*. London, 1977.
Marshall, F.H. *Catalogue of the Finger Rings, Greek, Etruscan and Roman, in the Departments of Antiquities, British Museum* (BMCR). Oxford, 1907 (reprinted 1968).
Marshall, F.H. *Catalogue of the Jewellery, Greek, Etruscan and Roman, in the Departments of Antiquities, British Museum* (BMCJ). Oxford, 1911 (reprinted 1969).
Petrie, W.M.F. *Objects of Daily Use*. London, 1927.
Pierides, A. *Jewellery in the Cyprus Museum*. Nicosia, 1971.
de Ricci, S. *Catalogue of a Collection of Ancient Rings formed by the late E. Guilhou*. Paris, 1912.
Ross, M.C. *Catalogue of the Byzantine and Early Medieval Antiquities in the Dumbarton Oaks Collection, Volume 2: Jewelry, Enamels and Art of the Migration Period*. New York, 1965.
Siviero, R. *Jewelry and Amber of Italy*. New York, 1959.
Venedikov, I. and Gerassimov, T. *Thracian Art Treasures*. London, 1975.
Walters Art Gallery. *Jewelry, Ancient to Modern*. New York, 1980.
Williams, C.R. *Catalogue of Egyptian Antiquities, Numbers 1–60, Gold and Silver Jewelry and Related Objects*. New York, 1924.
Winlock, H.E. *The Treasure of Three Egyptian Princesses*. The Metropolitan Museum of Art, New York, 1948.

Journals
The only journal specifically dealing with jewellery history is *Jewellery Studies*, published by the Society of Jewellery Historians, c/o Department of Prehistoric and Romano-British Antiquities, British Museum, London. This same society organises lectures and conferences on all aspects of jewellery history and keeps members up to date on similar events worldwide. Many other archaeological journals contain the occasional article on ancient jewellery and the abstracting journal *Art and Archaeology Technical Abstracts*, published by the Getty Conservation Institute in association with the International Institute for Conservation, includes articles on technical aspects of ancient jewellery.

The Institut Supérieur d'Archéologie et d'Histoire de l'Art, Université Catholique de Louvain, Louvaine-La-Nieuve, Belgium publishes a series called *Aurifex*, edited by T. Hackens, that covers various aspects of ancient jewellery.

Index

Page numbers in bold refer to illustrations

8762